CW00410684

FROM LANCASHIRE to YORKSHIRE by CANAL

FROM LANCASHIRE to YORKSHIRE by CANAL

In the 1950s

ANDREW HEMMINGS
& DAVID SWIDENBANK

Andrew Hemmings

AMBERLEY

To our children;
Sarah Harwood, Emma and Ross Hemmings,
and Andrew Swidenbank

First published 2012

Amberley Publishing
The Hill, Stroud
Gloucestershire, GL5 4EP

www.amberley-books.com

Copyright © David Swidenbank & Andrew Hemmings 2012

The right of David Swidenbank & Andrew Hemmings to be identified as the Author
of this work has been asserted in accordance with the
Copyrights, Designs and Patents Act 1988.

All rights reserved. No part of this book may be reprinted
or reproduced or utilised in any form or by any electronic,
mechanical or other means, now known or hereafter invented,
including photocopying and recording, or in any information
storage or retrieval system, without the permission in writing
from the Publishers.

British Library Cataloguing in Publication Data.
A catalogue record for this book is available from the British Library.

ISBN 978 1 4456 0341 4

Typeset in 10pt on 12pt Sabon.
Typesetting and Origination by Amberley Publishing.
Printed in the UK.

CONTENTS

ACKNOWLEDGEMENTS

We are extremely grateful to Ben Lynch, Judith Eastwood and Jean Blackledge for providing the raw material for this book in the form of photograph albums, documents and interviews.

Thanks to the *Lytham St Annes Express* newspaper, we were contacted by two former cadets from Lytham Sea Cadet Corps, David Appleton and Bruce McCalla. At Hull we enjoyed unqualified support from past and present members of the Hull Sea Cadet Corps (SCC) Committee. These include Vic Chandler, Freda & Brian Cheeseman, Susan Coupland, Gordon Slater, CO Jacqui Gorman, Capt Brian Pearson and Lena Slater.

On our journey across England we were fortunate to encounter lock-keepers, boaters and members of the general public who were unfailingly helpful. At Tarleton, Bingley and Castleford we should like to thank Harry Major, Barry Whitelock MBE and John Lobley, and Carol of British Waterways. On the water we enjoyed the company of Beth & Fred Thompson (*Dignity*, Wigan), John Norris (*Kestrel*), Nick Osborne (*Dalesman*, Skipton – Pennine Boat Trips), Steve Jones (*Muddy Waters*, built in Knottingley) and the crew of the *Telethon Louise*, Yorkshire Waterways Museum. We are also grateful to the officers and members of the Commercial Boat Owners Association (CBOA), David Lowe, John Dodwell and Jonathan Branford.

On land, we were helped by Rob Dunham of Burnley, David Penney and Derek Jennings of the Skipton and East Lancashire Rail Action Partnership (SELRAP), by Ray B. Smith with his information about Whitebirk Power Station, by Paul Gibson with his detailed knowledge of West Parade, Hull, and David Hull for advice about the railways around Burscough and Renee Martin with information about Turkish names.

Andrew Hemmings acknowledges the encouragement from the Chartered Institute of Logistics and Transport UK (CILTUK), particularly Richard Barratt, Neil Caldwell, Donna Cresswell, Peter Huggins and Nigel Kirkwood. Similarly he appreciates the support of his wife, Jill, son Ross and sister, Anne Lynch, daughters Sarah Harwood and Emma Hemmings.

Thanks also go to Chris Swidenbank who accompanied both Andrew and her photographer husband David on the 2011 journey providing research and final editing support, not forgetting the tea, sandwiches and cake.

The typing was expertly done by Maggie Wright.

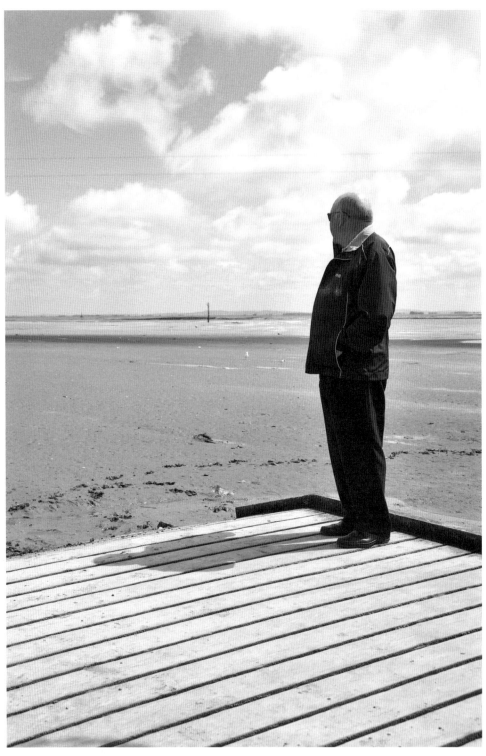

Ben Lynch at Lytham Jetty, 2011.

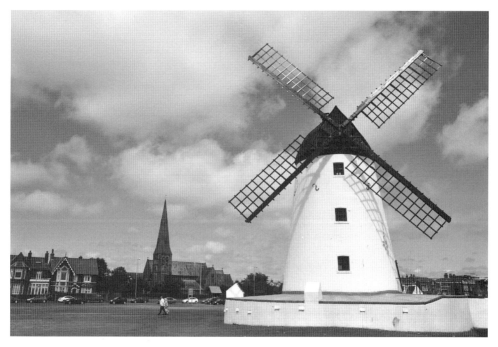

Lytham Windmill, 2011.

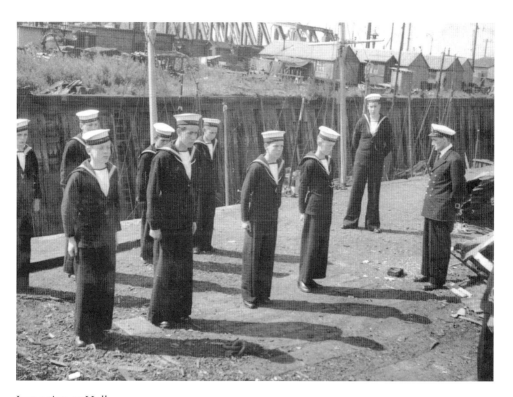

Inspection at Hull.

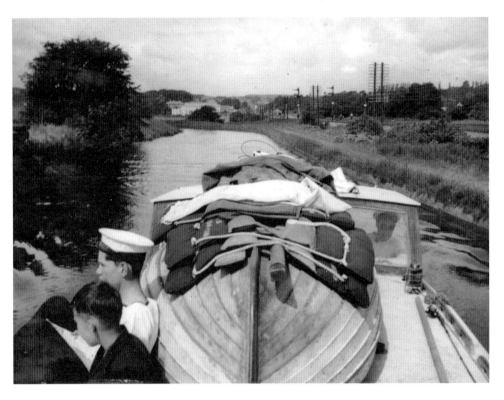

Above: Cruising along.

Left: Hessle Windmill, 2011.

INTRODUCTION

On 19 July 1958, eleven sea cadets and three officers from Lytham SCC set off on an historic boat trip across England. Whilst it was customary for sea cadets to attend an annual summer 'camp' this venture was unique in a number of ways. It was to prove an ambitious and testing journey, far exceeding in geography and navigation the 1957 voyage to Skipton and the 1959 outing to Piel Island, Barrow in Furness, undertaken by the unit.

The crew sailed the Training Ship (TS) *Queenborough* across the tides of the Ribble Estuary, up the River Douglas to the Rufford Branch of the Leeds & Liverpool Canal. From this semi-derelict waterway they joined the main line of the Leeds & Liverpool at Burscough Bridge, then headed east and north through the manufacturing towns of Lancashire, Wigan, Blackburn and Burnley. They experienced the Wigan Flight of Locks, Gannow Tunnel, the Burnley Embankment and Foulridge Tunnel before crossing the Pennines into Yorkshire.

Next came the challenge of Bingley Five Rise Locks before the village of Saltaire and the industrial city of Leeds. Here they joined the Aire & Calder Navigation through Castleford and Knottingley to Goole Docks. At Goole they were met by members of Hull Sea Cadet Corps who, sailing their naval MFV 62, came to escort TS *Queenborough* across the tricky waters of the Humber Estuary to Kingston upon Hull. Their arrival was marked by the formalities of Navy life including inspections, church service and parades, also called Divisions, on Sunday 27 July 1958.

The return journey was accomplished in the following seven days which required expert and swift operations of the locks throughout the entire route back to Tarleton.

A trip of this magnitude enabled the cadets to see regular merchant shipping on the Humber as well as the dying throes of commercial traffic on Britain's canals. They saw coal and general purpose barges and buttys on a waterways network that looked dangerously tired, neglected and almost finished. There were occasional glimpses of 'pleasure boats' but no indication that such craft and their owners were to be the salvation and resurrection of Britain's waterways.

Most remarkable of all is the fact that virtually the entire journey was photographed by Alf Firby, one of the officers. These photographs have survived in the care of one of

the ex-cadets, Ben Lynch, who was fifteen years old when he made this fascinating trip. Duplicate sets of photographs in detailed albums have also been recently discovered in the ownership of Judith Eastwood and her mother Jean Blackledge. Jean is the widow of Lt Blackledge, the first officer on TS *Queenborough* in 1958.

Based on these documents, interviews with Jean Blackledge, Judith Eastwood and Ben Lynch we have recreated the Captain's Log for TS *Queenborough*. This is reproduced as part of the first chapter to show the meticulous detail put into planning and achieving this expedition.

Using many of the photographs taken in 1958 and combining them with a selection of stunning new images of the same locations today, the subsequent chapters show how canal and sea cadet life has changed over the last fifty years.

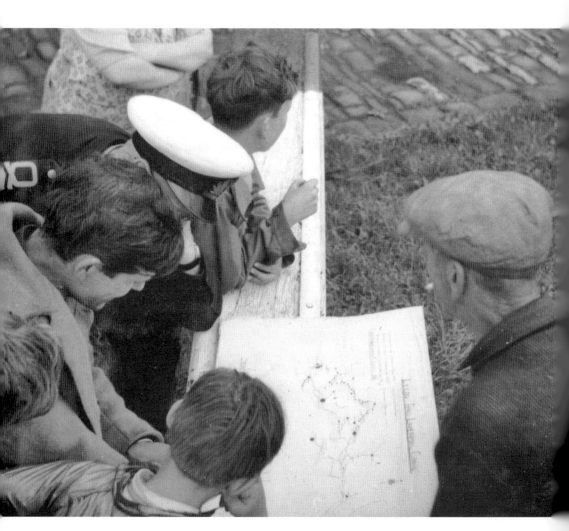

Lt Terry Blackledge and his crew.

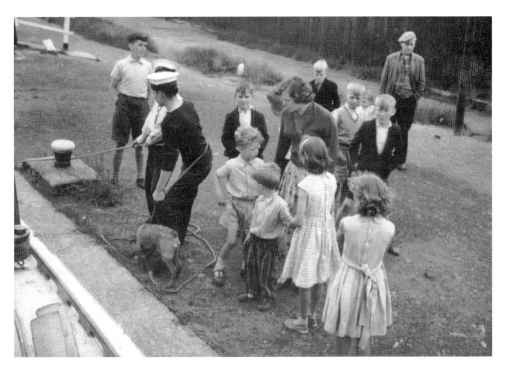

Interested locals.

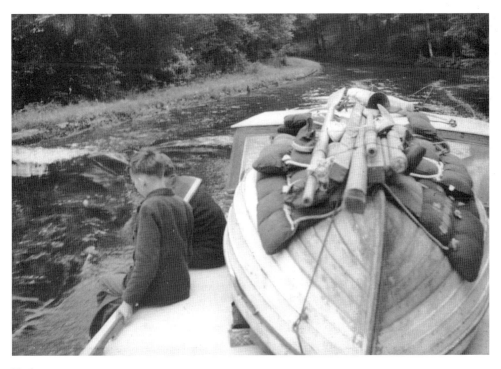

Underway.

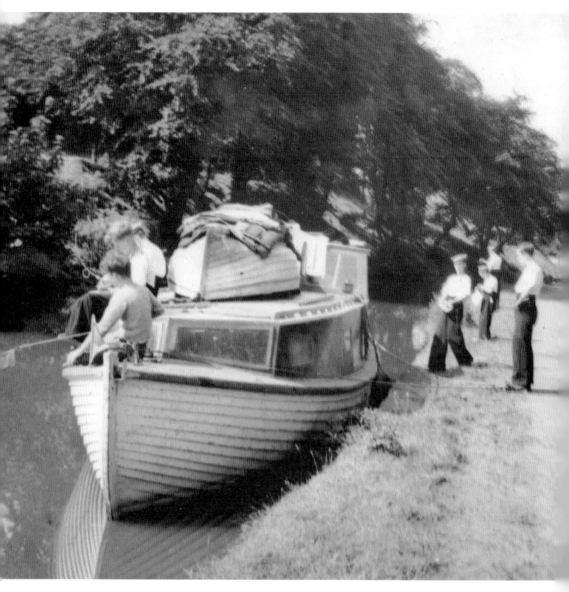

Break in the journey.

CAPTAIN'S LOG:
TS *QUEENBOROUGH*

Sunday 20 July to Saturday 2 August – A Journey by Lytham SCC by River and Canal from Lytham (West Coast) to Hull (East Coast) and Return

Sunday 20 July
Left Lytham 12.30 p.m. Sailed up the River Ribble and the Douglas to Tarleton, entered the canal system at Tarleton. Through the Rufford stretch to join the Leeds & Liverpool Canal at Burscough Bridge, stayed the night at Burscough. The Rufford stretch was very weedy in parts, and the swing bridges were in bad repair. We had to resort to towing the cutter from the canal bank in places.

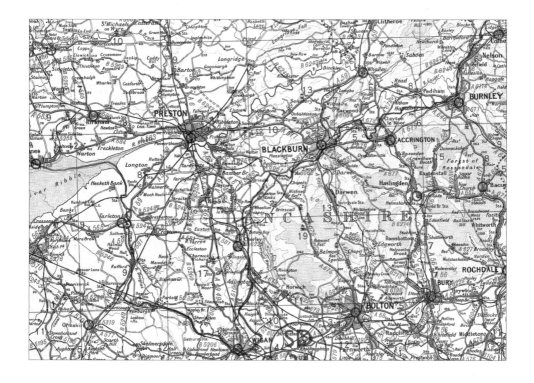

Monday 21 July

Left Burscough, passed Parbold to Lower Ince at Wigan, through twenty-three locks to Higher Ince, about 300 feet higher. Left Wigan, on through Adlington and Chorley to Blackburn. Stayed the night outside Blackburn.

Tuesday 22 July

Left Blackburn to Clayton-Le-Moors, Gannow Tunnel, Burnley, Nelson and Barrowford, on to Foulridge, through Foulridge Tunnel about 1 mile long. On to Barnoldswick, West Marton and to Gargrave where we stayed the night.

Wednesday 23 July

Left Gargrave, on to Skipton, few hours stay at Skipton, left Skipton on to Keighley and Bingley, down the Five Rise Locks at Bingley. On to Saltaire, Shipley, Thackley and Apperley Bridge. Stayed the night at Apperley Bridge.

Thursday 24 July

Left Apperley Bridge on to Calverley, Kirkstall, Bramley and Leeds, left the Leeds & Liverpool Canal at Leeds and entered the Aire & Calder River Navigation on to Knottingley and to Whitley Bridge. Stayed the night at Whitley Bridge.

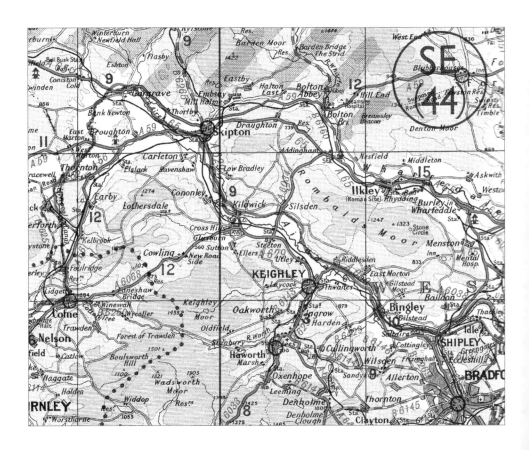

Friday 25 July
Left Whitley Bridge on to Goole, stayed the night at Goole.

Saturday 26 July
Met by the Hull SCC boat and escorted down the Ouse and Humber to Hull. Stayed the night at Hull, using Hull SCC's boat for sleeping quarters.

Sunday 27 July
Met by Hull SCC Leading Cadet and taken to attend Divisions at Hull SCC Headquarters. (Training Ship *Revenge*) toured the headquarters. Left Hull during the afternoon, sailed up the Humber and Ouse to Goole, re-fuelling and taking water at Goole, left and on to Whitley Bridge. Stayed the night.

Monday 28 July
Left Whitley Bridge on to Leeds, and from Leeds to Apperley Bridge, stayed the night at Apperley Bridge.

Tuesday 29 July
Left Apperly Bridge and on to Skipton. Stayed the night at Skipton.

Wednesday 30 July
Left Skipton to Barrowford, stayed the night at Barrowford.

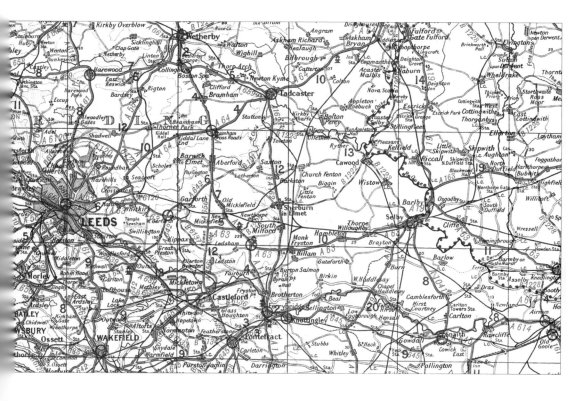

Thursday 31 July
Left Barrowford and on to stay at Clayton-Le-Moors.

Friday 1 August
Left Clayton-Le-Moors, on to Wigan, down the twenty-three locks at Wigan and on to stay the night at Apperly Bridge.

Saturday 2 August
Left Apperly Bridge, on to Tarleton Lock, missed the tide for entering the tidal River Douglas. Tied up the cutter and left Tarleton by train via Preston to Lytham.

Total Distance covered: c. 400 miles

No. of Locks Negotiated: c. 206

Diesel Fuel Oil Used: c. 40 galls

Water for Washing, Cooking etc.: 500 galls

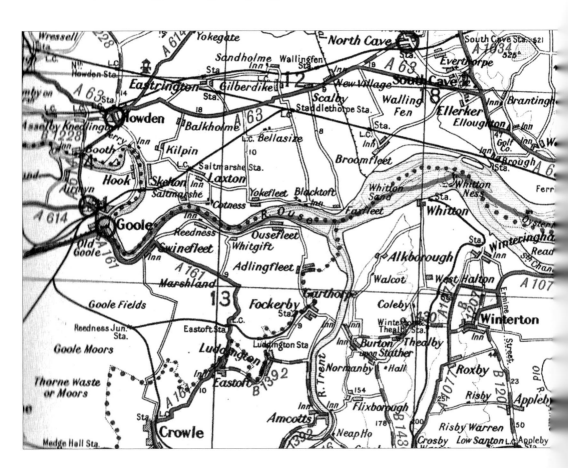

1

THE BOAT:
TS *QUEENBOROUGH*

This 32-foot cutter with draught of 2 feet 6 inches was given by the Admiralty to Lytham Sea Cadets Corps to sail as a Training Ship around 1955. It was originally a sea-going boat designed to be rowed by twenty ratings though it was subsequently fitted with a diesel engine. The Sea Cadets fitted a superstructure on it, mooring the boat in the river during the summer and in Lytham (also known as Dock) Creek in the winter. The awning at the rear of the boat provided accommodation for officers during voyages whilst the cadets slept in a big bell tent when cruising inland waters, unless the weather was too inclement; in these circumstances all the cadets squeezed into the cramped accommodation of the forward section.

HMS *Queenborough*

The Training Ship was named after HMS *Queenborough*, a Q – or Quilliam – Class Fleet Destroyer of the Second World War. She was laid down by Hawthorn Leslie, Newcastle upon Tyne on 6 November 1940, launched on 16 January 1942 and completed on 10 December that year. The build cost was £439,280 excluding Admiralty-supplied equipment such as guns, wireless and radar.

This was the sixth warship to carry the name, last used for a sixth rate in 1747. The designation 'sixth rate' was used by the Royal Navy for small warships mounting between twenty and twenty-four nine-pounder guns on a single deck, sometimes with guns on the upper works and sometimes without.

Following a successful Warship Week for National Savings during March 1942, she was adopted by the Borough of Lytham St Annes. Warship Week was a fund-raising scheme to encourage civilians to save their money in government accounts such as War and Defence Bonds, Saving Bonds and Certificates. In 1942 it was decided that the national scheme would be around 'adopting a warship'; it coincided with a week of parades, exhibitions and other war paraphernalia.

HMS *Queenborough* served with battle honours in the Arctic Ocean, Mediterranean Sea, Indian and Pacific Oceans. She was assigned to the 4th Destroyer Flotilla before transfer to the Royal Australian Navy in November 1945.

According to Ben (Bernard) Lynch, its namesake, the 32-foot cutter, was a good boat for the trip across the estuaries and along the canals and rivers of England. In 1957 Lytham Sea Cadets took TS *Queenborough* across the Ribble Estuary and along the Leeds & Liverpool Canal to Skipton and back. David Appleton, a Lytham cadet in 1957 before moving to Canada recalls that this was good experience for the adventure of 1958 when they were to bisect England navigating the Ribble Estuary, the Leeds & Liverpool Canal, the Aire & Calder Navigation and the Humber Estuary. Ben remembers that the cadets spent three weeks before the voyage painting and preparing the boat whilst it was moored in the River Ribble. It was an exciting prelude to a great holiday adventure for the group of boys.

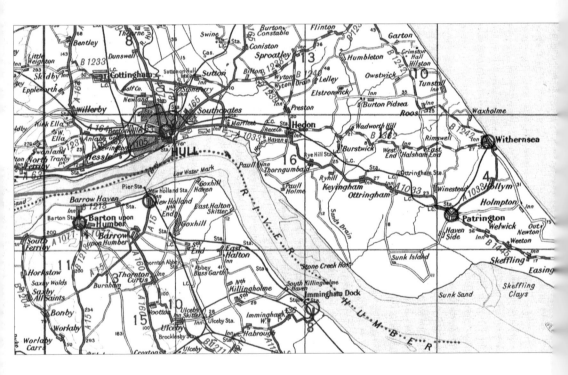

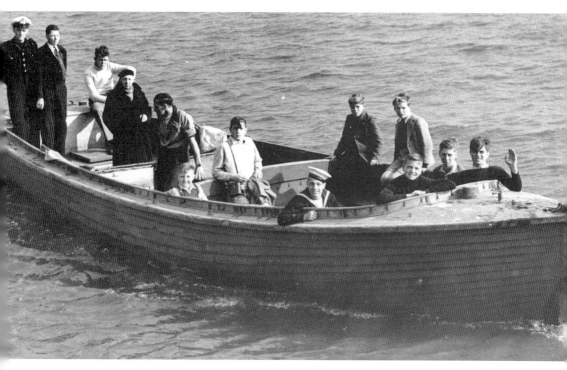

Original boat.

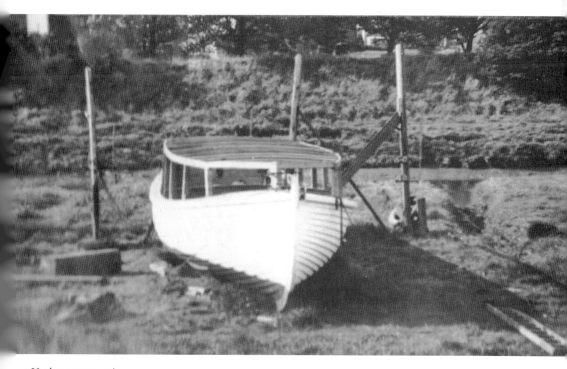

Under construction.

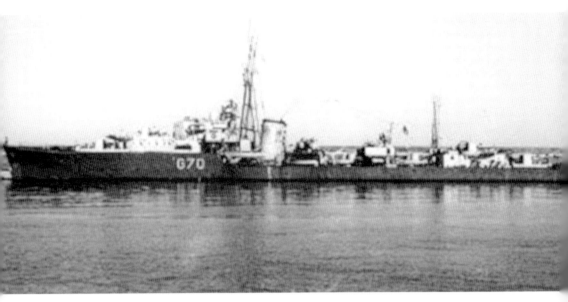

HMS *Queenborough*.

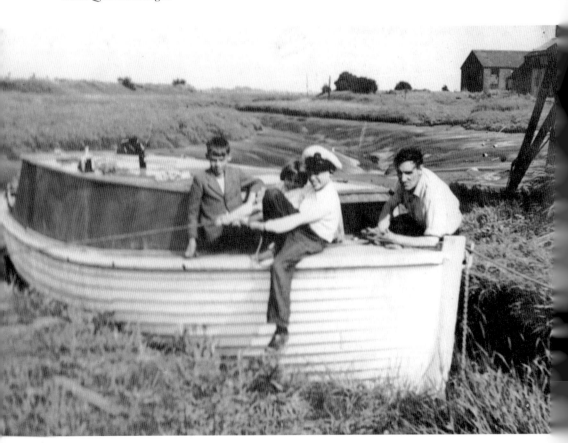

Lytham (Dock) Creek.

The Crew: Lytham Sea Cadets

In the 1950s the Sea Cadet Corps catered for boys aged eleven or twelve upwards who might be interested in a career as sailors in the Merchant or Royal Navy. Lytham Sea Cadets Corps had their land-based headquarters at Customs Watch House in Lytham. The Watch House has long been demolished and the site is presently occupied by Birkenhead House, erstwhile home of the Land Registry. The present headquarters is at Haven Street, Lytham. Ben Lynch and Andrew Hemmings are photographed outside the modern-day HQ, holding a picture of Ben Lynch at Hull on Sunday 27 July 1958.

Ben Lynch was aged fifteen and had left school early to take part in the trip. His fellow cadets include his friend Jimmy Simpson, Bruce McCalla, 'Dave' Smeeton, Brian Pearson, J. Bowers, Charles Godfrey and Dave and Steven Firby.

The cost of the trip was generally paid by the parents, although Ben Lynch did two paper rounds in those days, one before school and one after. He also caddied at the Old Links Golf Club during holidays and at weekends. All those who wanted to go went; some cadets would have gone away with their parents as it was the summer holidays.

The expedition was led by Lt Terry Blackledge, ex-Royal Navy, accompanied by Engineer Petty Officer Ken Firby and his cousin Alf Firby. We are indebted to Alf for taking the photographs.

We were fortunate to get in touch with the widow and daughter of Terry Blackledge who provided a further set of photographs and a wealth of vivid memories. Jean Blackledge recalled how her husband and Ken Firby had the vision of Lytham Sea Cadets making the trip from the West to East Coast, travelling the estuaries, canals and river navigations of England. It was a dream reinforced by in-depth discussions and planning at the County Hotel, Lytham and the Becconsall Arms, Tarleton.

The accompanying photograph shows Judith Eastwood and Jean Blackledge with an evocative photograph of Lt Terry Blackledge.

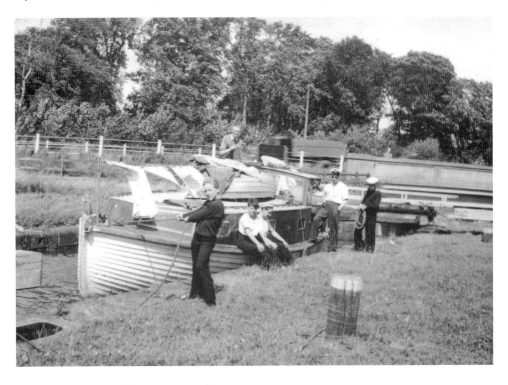

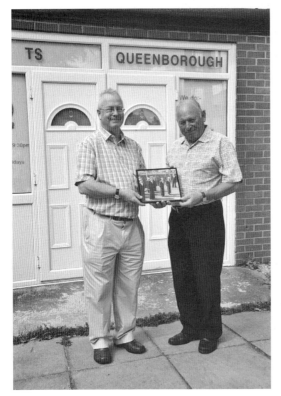

Above: Washing days.

Left: Ben Lynch and Andrew Hemmings at present headquarters, 2011.

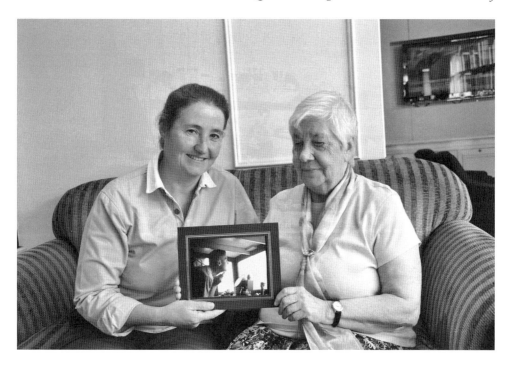

Above: Jean and Judith, 2011.

Right: Wet weather duty.

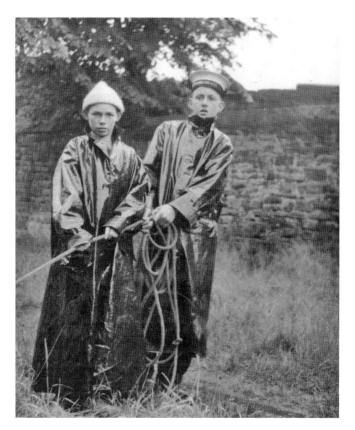

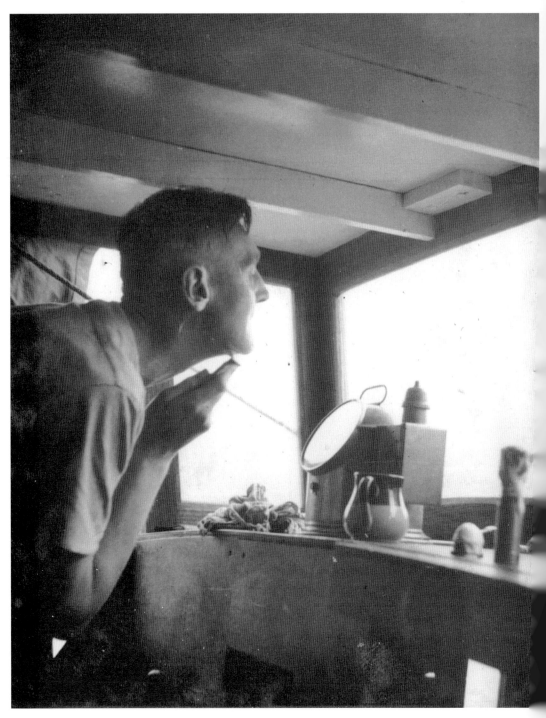

Lt Terry Blackledge.

2

LYTHAM TO WIGAN

Lytham to Tarleton

TS *Queenborough* left her moorings at Lytham around lunchtime on Sunday 20 July, sailing across the Ribble Estuary and entering the River Douglas at high tide. As the River Douglas is a tidal river, the Rufford Branch of the Leeds & Liverpool Canal can only be entered via Tarleton Lock (No. 8) at high water.

The 1958 photographs show that the boat came up on the tide, sailed past the lock before reversing on the bend with the bow downstream. The dinghy was towed behind before being hauled ashore and on to the roof of TS *Queenborough* at the boatyard of James Mayor & Co.

At Tarleton Alf Firby photographed the lock-keeper's cottage. This still survives though it looks very different today as it is enveloped by a modern outer skin. Harry Mayor, the present lock-keeper, was lock-keeper at the time of the Sea Cadet Corps' trip. He remembers parties of sea cadets from both Lytham and Preston coming through the lock. He explained that in 1958 the Rufford Branch of the canal had been designated as 'remainder' status – one step above a derelict canal. Apart from access to the boatyard it was last used in the 1940s to carry stone to the 'Training Walls' being built out in the estuary of the River Ribble. Following the Transport Act of 1968 the Branch was upgraded to a national 'cruiseway'. This formal classification meant that the canal was maintained to a level whereby cruising craft could safely navigate the length of the waterway. The 1968 Act of Parliament was a pivotal moment in the history of British waterways, officially recognising the transition from commercial to leisure traffic. This change came fully ten years after the pioneering voyage of the Lytham Sea Cadets.

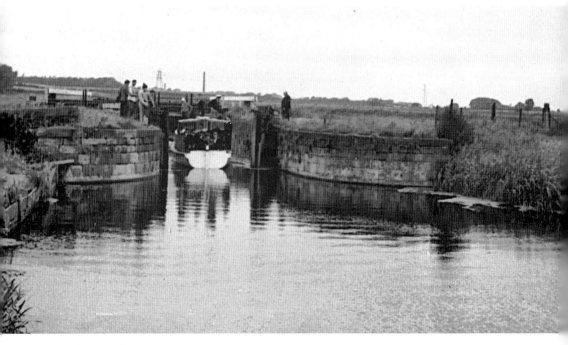

Tarleton Locks – reversing out.

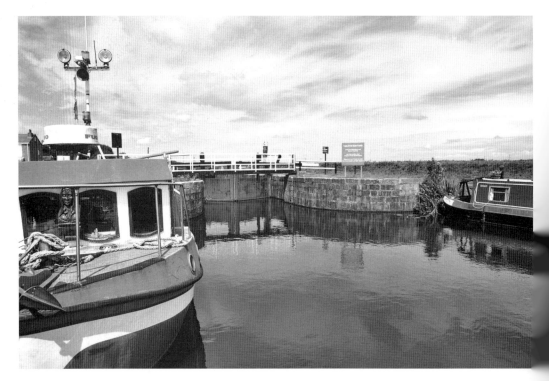

Tarleton Lock, 2011.

Dinghy hauled ashore at Mayor's Boatyard.

Mayor's Boatyard, 2011.

Lock-keeper's cottage.

Lock-keeper's refurbished cottage, 2011.

Inset: Harry Mayor.

Tarleton to Ring O' Bells

Terry Blackledge, Ben Lynch and Harry Mayor all described how, in 1958, the Rufford stretch was neglected, overgrown and full of chickweed. As TS *Queenborough* had a water-cooled diesel engine, the chickweed clogged the filter, meaning that all the cadets had to manhandle the craft, hauling it by rope from the towpath.

In addition the swing bridges, now so immaculate, proved very difficult to open. At one point the crew needed the help of a local farmer to open and close a swing bridge. It may have been along this stretch that the cadets were surprised to see a dead pig floating in the water. 'Dave' Smeeton was promptly sick at this sight.

Setting off along the Rufford Branch of the Canal, TS *Queenborough* went past the warehouse and under Tarleton Bridge (No. 11) which carried the A59 Trunk Road from Preston to Liverpool. The canal occupies the original line of the River Douglas while the river has been diverted to a new cut.

In 2011 we found that there was no towpath at this point, the footpath was overgrown and the warehouse boarded up. Even after two centuries, the river character is obvious with tall reeds, oak trees, yellow irises and foxgloves.

Between Rufford and Burscough the canal is crossed by a railway bridge on the Preston to Ormskirk Line. This bridge is a most unusual x-shape since it contains a level crossing over the canal. In 1958 this was being used by a herd of cows apparently accompanied by a lone car. Our visit in 2011 showed that the bridge and level crossing have both survived.

The Sea Cadets joined the main line of the Leeds & Liverpool Canal at Burscough and cruised on to the 'Ring O' Bells'. They camped by Bridge No. 34 in one large tent on the canal side. On tying up for the night, the evening meal was eaten whilst cadets took turns to wash up and clear away. As it was light until late they were allowed off the boat to explore the local countryside with instructions not to stray too far. Officers were known to visit the local hostelry though never for more than hour or so.

Lights were out on their return; the lads told jokes and stories until they all fell asleep. Ben remembers that ghost stores were a favourite to frighten the more timid members of the crew.

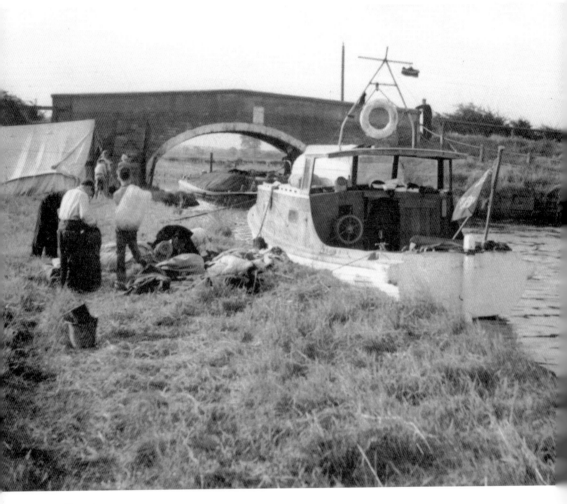

Camping.

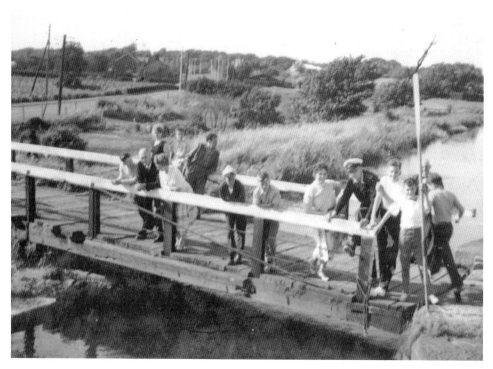

Swing Bridge No. 8.

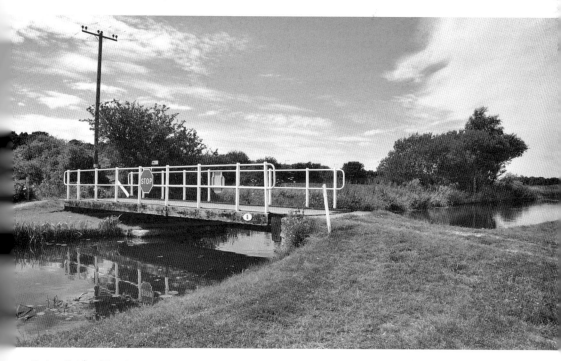

Swing Bridge No. 8, 2011.

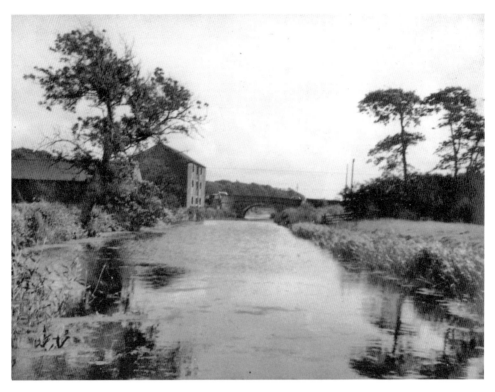

Warehouse and road bridge.

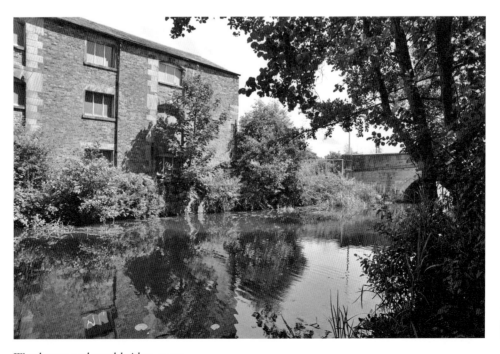

Warehouse and road bridge, 2011.

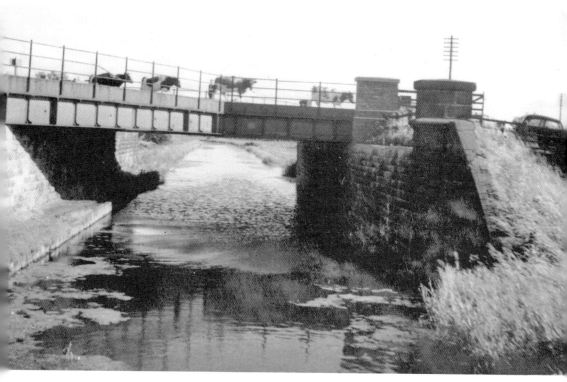

Level crossing and railway bridge with cows.

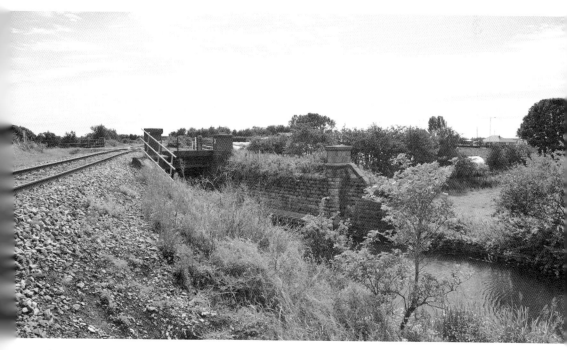

Level crossing and railway bridge, 2011.

Ring O' Bells to Wigan

As the Sea Cadets approached Wigan they encountered a group of children, probably on the lock side. The children did not appear too friendly. Ben Lynch asked if they were in Wigan; the reply came that it was 'Wigin'. One of the children threw a bird's egg at Ben, which hit his friend Jimmy Simpson. Such hostility was unusual. Often the boat would pick up children on the canal side and give them a lift to the next lock. The cadets exchanged information and views about schools, showed visitors the boat and told them about the Sea Cadet movement. It was a very informal social interaction, very alien to children in the twenty-first century.

At Wigan the crew stopped at the water supply point before Wigan Bottom Lock (No. 87) to fill their tank before attempting the twenty-three locks of the Wigan Flight. The Captain's Log originally referred to twenty-seven locks though the second edition of the Geo Projects Guide to the Leeds & Liverpool Canal now counts twenty-three from Wigan Top Lock No. 65 to Bottom Lock No. 87.

The *AA Road Book* of 1958 describes Wigan as an important coal-mining town. Coal was transported from here by barge along the Leeds & Liverpool Canal westwards to the Tate & Lyle factory at Liverpool. It was George Orwell's *Road to Wigan Pier*, written in the 1930s, that made the town's name. Located between the A49 bridges, it developed a joke by George Formby in his comparison with the piers of Blackpool and Southport. The original 'pier' was built as a tippler that loaded coal in railway wagons from Meyrick Bankes' collieries into narrow boats, and dismantled in 1929. As the current replica was not built until 1984 the cadets would have seen no evidence of the famous pier. They would have seen the Wigan Warehouses of 1890, now home to the Orwell and Pier Nightspot.

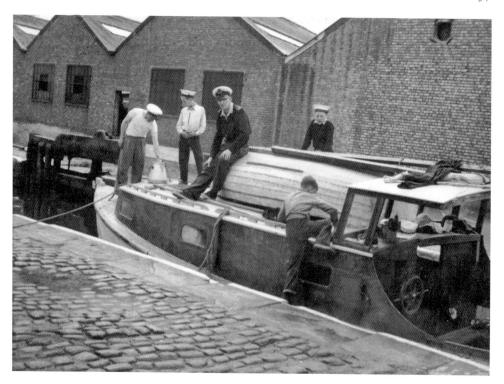

Taking water.

Wigan Bottom Lock, 2011.

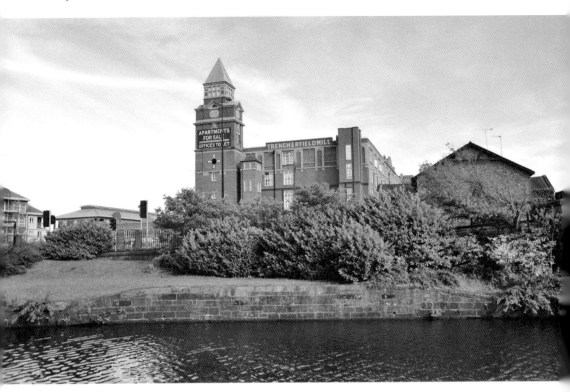

Trencherfield Mill, 2011.

The Orwell.

3

WIGAN TO SKIPTON

Blackburn

The coal-carrying barges at Whitebirk Power Station, Blackburn, caught the eye of the photographer, Alf Firby in 1958. According to local historian Ray B. Smith the photograph was taken from under the bridge that carries the dual carriageway Whitebirk Drive to the roundabout. The picture is looking east towards Accrington and the cooling towers on the left are now replaced by the retail park car park beside the canal.

Whilst some of the retail units in Greenbank Business Park are now closed, the location is distinguished by an electricity substation and radiating power lines. The power station opened in 1921 and closed in 1976. In 1958 Blackburn was described as 'an important cotton-weaving centre'.

The Leeds & Liverpool Canal is crossed at this point by three bridges (104A, B, C) dated 1996. We found that it is just possible to visualise operations on the canal with barges loaded at the wharf serving Bank Hall Colliery, Burnley and discharged at Whitebirk Power Station.

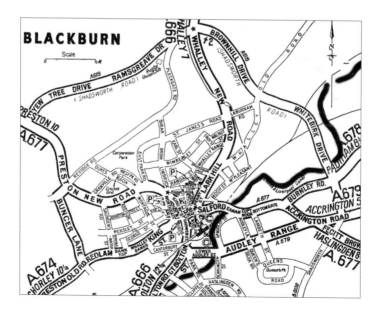

Map of Blackburn.

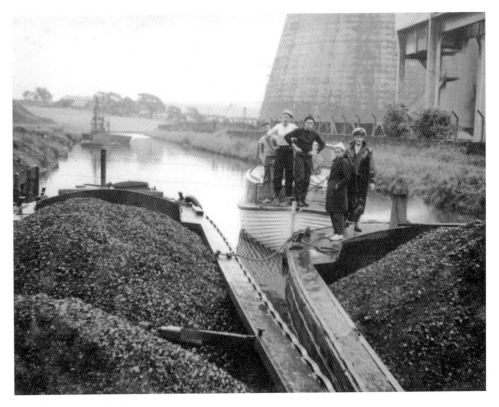

Blackburn Power Station.

Site of Blackburn Power Station, 2011.

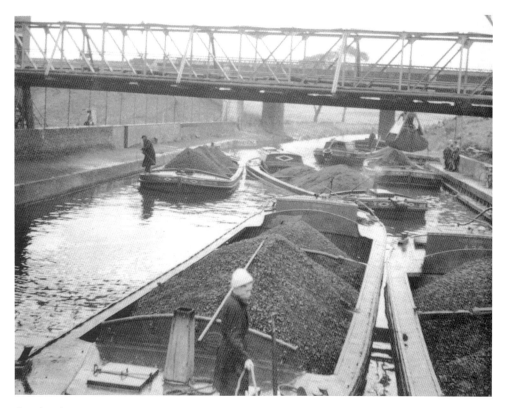

Overhead conveyor.

Foundations of conveyor, 2011

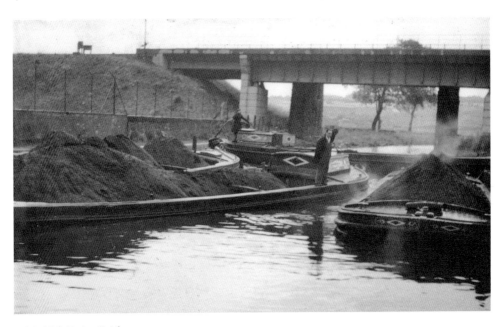

Whitebirk Drive Bridge.

Bridge 104C, 2011.

Burnley

These barges came along the Burnley Embankment and through the Gannow Tunnel. We visited both locations in 2011 following the route of the Lytham Sea Cadets. Although the portals of Gannow Tunnel are just about recognisable from Alf Firby's photographs, we faced a post-modern urban landscape in trying to walk from the south-west to north-east portal. Fortunately we were rescued by a chance encounter with local resident Rob Dunham who kindly guided us across the roundabout on Gannow Top Road and down Boat Horse Lane to rejoin the canal towpath. Our subsequent route into Burnley took us past the Weavers' Triangle Visitors' Centre towards the most changed location, the view from the Burnley Embankment. In 1958 Burnley was an industrial town engaged in coal, iron and cotton. The Embankment is known locally as 'the Straight Mile' and carries the canal 60 feet above the rooftops of Burnley giving a bird's-eye view of the town. This is Britain's most outstanding canal embankment, one of the wonders of the waterways, perhaps less impressive from above than from below. From the towpath it gives views over the slate roofs of the town, the green dome of the Town Hall, the Comfort Inn and Burnley Football Club.

The scene of the Odeon and the Yorkshire Hotel has altered completely from that day in 1958 when, on 22 July, *Gideon's Day* was showing at the Cinema. *Gideon's Day* was a 1958 British crime film directed by John Ford and starring Jack Hawkins, Dianne Foster and Cyril Cusack. An adaptation of John Creasey's novel of the same name, it was the first film to feature the character George Gideon of Scotland Yard, here played by Jack Hawkins. The cinema is now a distant memory, only recalled by a battered mosaic on the canal side on the Yorkshire Street Aqueduct (Bridge No. 130G). It has been knocked down and replaced by an anonymous-looking retail shed. We felt something of a sense of loss and forlornness which was accentuated by comparing the 1958 image of the Burnley Embankment with the scene in 2011, with only one mill chimney evident.

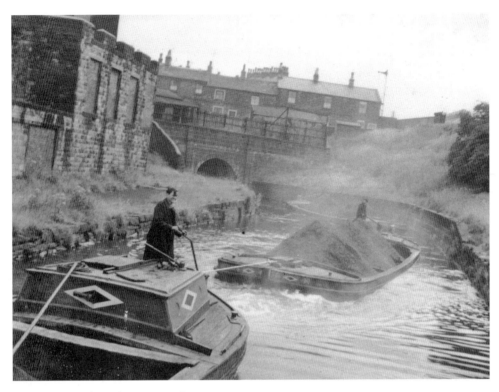

Gannow Tunnel south-west portal.

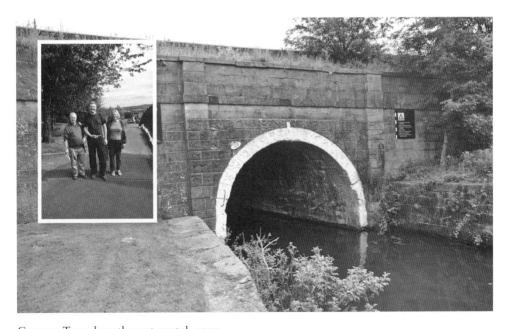

Gannow Tunnel south-west portal, 2011.

Inset: Rob Dunham.

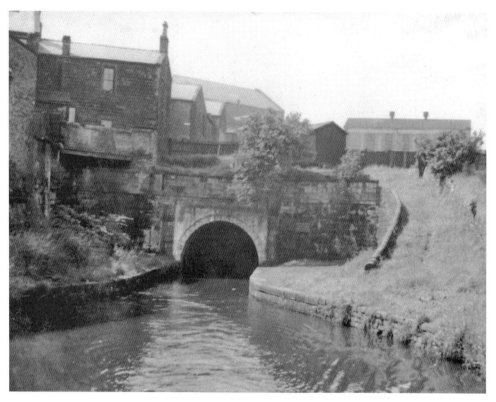

Gannow Tunnel north-east portal.

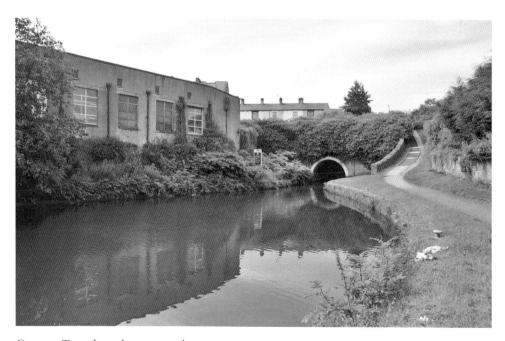

Gannow Tunnel north-east portal, 2011.

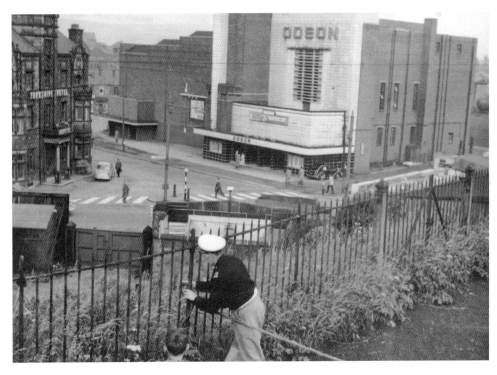

Odeon cinema.

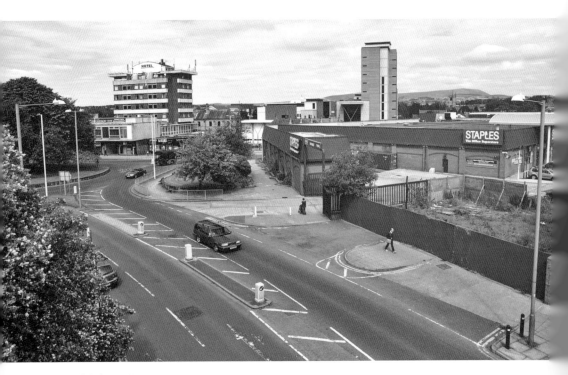

Site of Odeon cinema, 2011.

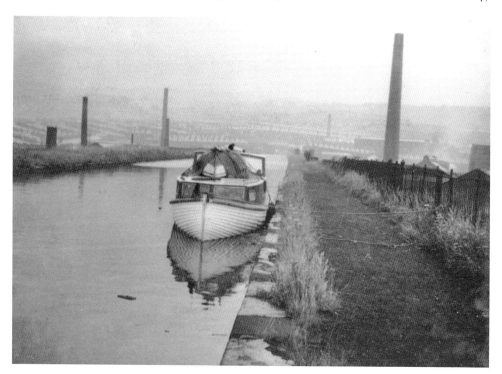

Burnley Embankment.

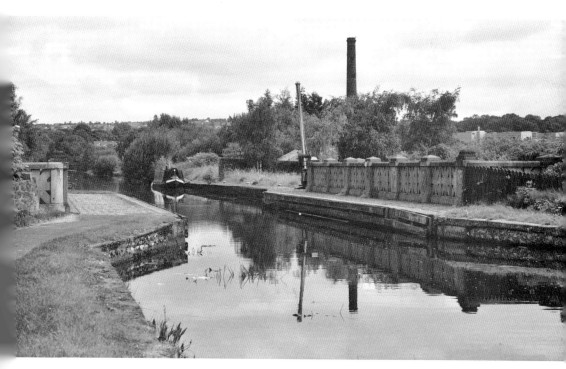

Burnley Embankment, 2011.

Foulridge

Fortunately, greater activity and enterprise awaited us at Foulridge where the Sea Cadets encountered the tunnel. At 1,640 yards long, it took six years to build, ran drastically over budget and collapsed three times. The tunnel has no towpath and steam tugs were used from 1880 to 1937 to pull boats through. The tugs were double-ended, unique to the Leeds & Liverpool Canal, to avoid them having to turn round at either end of the tunnel. Today, a traffic light system operates to give access to the tunnel.

In 1912, as local stories go, a cow called Buttercup fell into the canal by the mouth of the tunnel and struggled through to the other end before being hauled out and revived with a brandy from the nearby pub, the Hole in the Wall. As this pub was closed on our visit we retired to Café Cargo on Foulridge Wharf. Here we found a sign indicating an access point to the trackbed of the Skipton to Colne Railway. The line opened in 1848 and was closed in 1970. The Skipton and East Lancashire Rail Action Partnership (SELRAP) is currently working hard to secure re-opening of the railway to passenger and freight traffic.

Café Cargo, Foulridge, 2011.

Foulridge Tunnel, 2011.

East Marton

Another prominent feature photographed in 1958 and 2011 is the unique double-arched bridge (No. 161) at East Marton. The lower arch carried a packhorse bridge whilst a higher arch has been built to take the A59 trunk road. For walkers the Pennine Way follows the canal past the unexpectedly delightful settlement and tea shop at Abbots Harbour. For further refreshments the Cross Keys Inn is close at hand. In 1958 Alf Firby snapped the 'foreign hikers' on the canal side. The Captain's Log offers no explanation of their country of origin.

Canal Bridge.

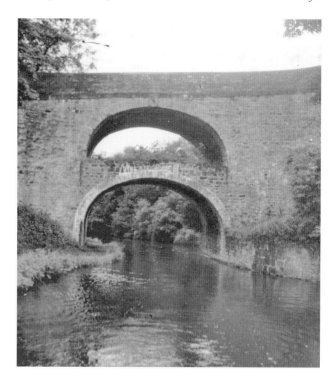

Double Arch Bridge, 1958.

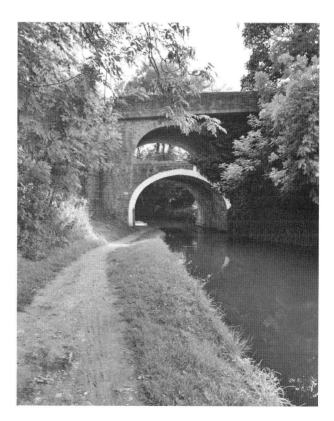

Double Arch Bridge, 2011.

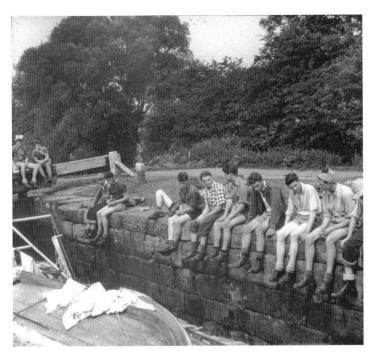

Left: 'Foreign
Hikers'.

Below: Pennine Way,
2011.

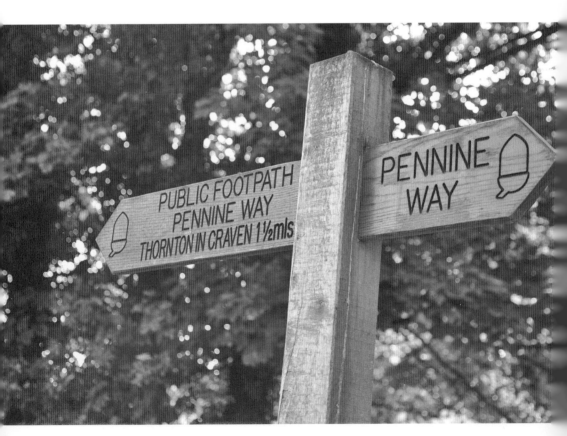

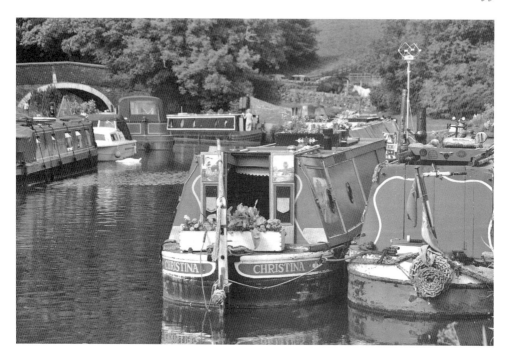

Above: Christina at East Martin, 2011.

Right: 'Castles and Roses'.

Gargrave

The cadets camped overnight at Gargrave, an attractive grey limestone town. Ben Lynch recalls that in fine weather the officers slept on board TS *Queenborough* while the cadets shared the tent pitched on the canal side. Some photographs show the cadets sleeping on boards on the boat, which only happened during heavy rainfall a couple of times on the trip. This was possible but not comfortable. At Gargrave the Leeds & Liverpool Canal runs alongside the Yorkshire Dales National Park. The area, covering 680 square miles, had been designated a National Park in 1954, four years before the Sea Cadets' adventure. Of more immediate concern to the officers and crew was the provision of fresh water, food and public conveniences. The officers stopped at regular intervals for food. TS *Queenborough* had a small galley on board with 'gas or primus of sorts', sufficient to cook baked beans and the like. Beans were the regular lunch whilst sandwiches were easy and quick. Fish and chips provided a happy alternative to officers' cooking from time to time. The Lytham Sea Cadets were never short of bread as their headquarters was next door to Cookson's, the local bakery. They set off with several loaves and possibly tea cakes and crumpets.

Fresh water was available via a water butt filled at the various stops along the route, for example at Wigan, Skipton and Goole. Morning routine started with a wash and brush up in the galley for those who could not avoid it. Washing was not a priority for fifteen-year-old boys. Washing facilities relied on a bowl filled from the water butt as in the picture of Lieutenant Terry Blackledge shaving using the compass binnacle. Toilets were restricted to public conveniences at stopping points as there were no sanitary stations as later provided by British Waterways.

The captioned photograph from 1958 shows an early morning start from Gargrave eastwards towards the market town of Skipton. In 2011 at Lock 32, Higherland Lock, we encountered Beth and Fred Thompson on their boat *Dignity*, registered in Wigan. We accompanied them to Lock 31, Eshton Road Lock, enabling us to take some boater's-eye photographs of the canal in 2011.

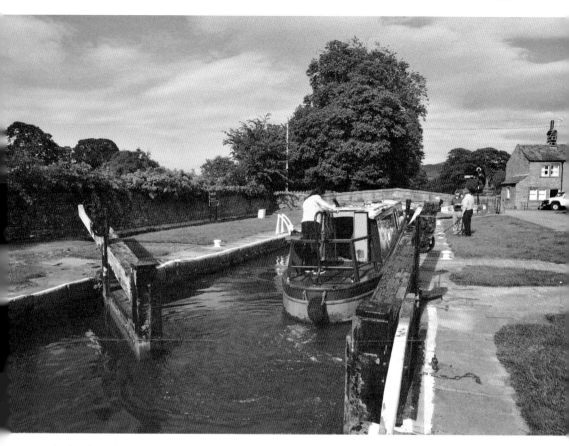

Higherland Lock, 2011.

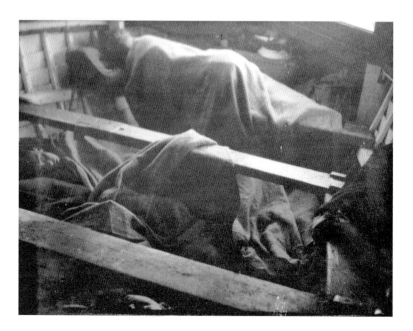

Sleeping on
board.

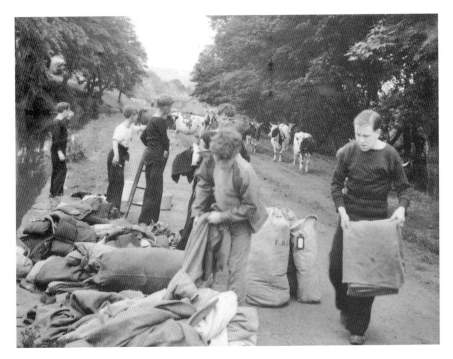

Cleaning ship.

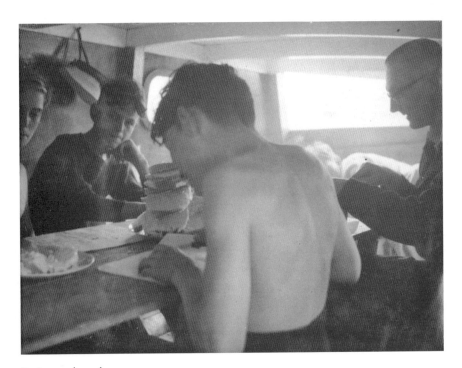

Eating on board.

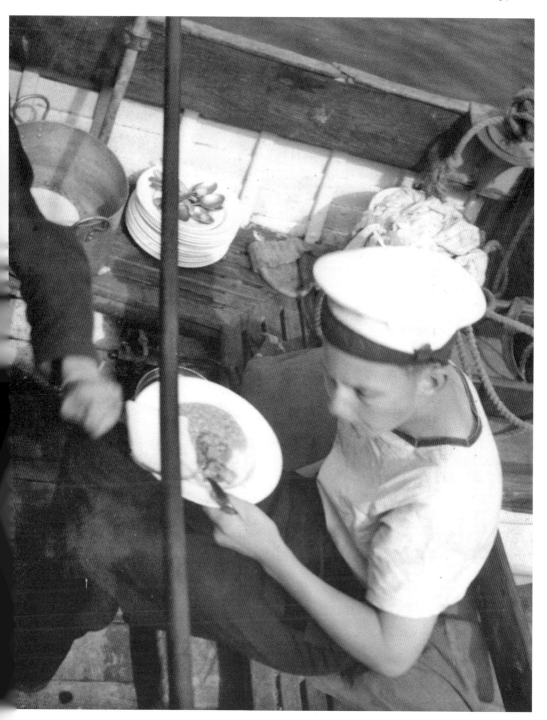

Bacon and beans.

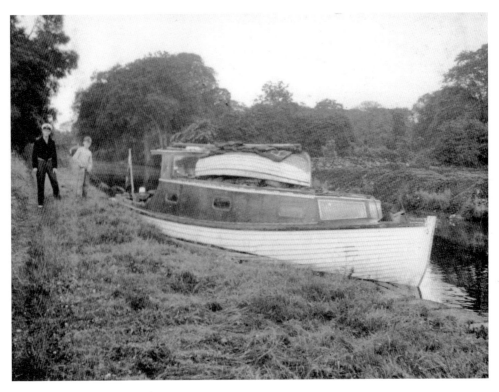

Lt Terry Blackledge and cadet.

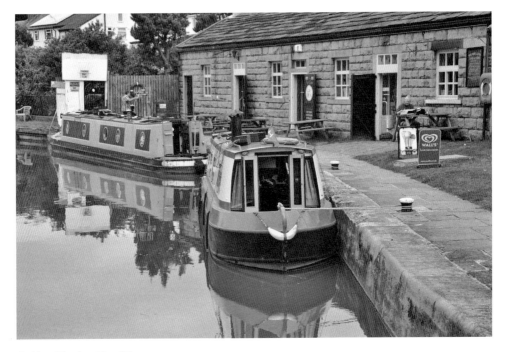

Café at Bingley Five Rise, 2011.

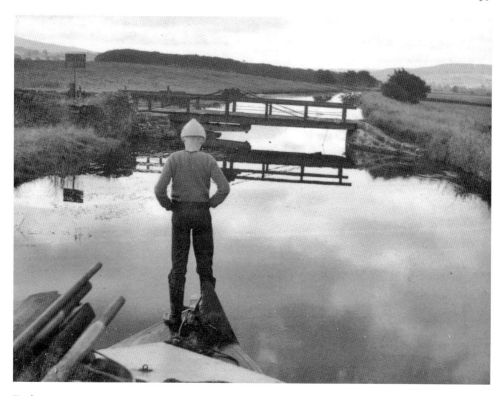

Early morning start.

Dignity, Gargrave, 2011.

Skipton

In 1958 TS *Queenborough* stopped in Skipton to take on water.

Our contemporary photograph shows a much-altered scene against the backcloth of the eighteenth-century canal buildings and bridges. The canal office of 1774 now houses Nick Osborne and his company, 'Pennine Boat Trips'. The overbridge is now clad in stone to blend with the surrounding buildings.

Away from the canal, the photographs show Holy Trinity Church, a perpendicular building partly twelfth-century and enlarged in the fourteenth century, and Skipton Castle.

The castle dates from 1090 and is one of the best preserved and most complete English medieval castles still roofed. It has a Conduit Court, a 45-foot-long banqueting hall decorated with seashells and a dungeon. Other features include a large kitchen, six fourteenth-century round towers, a seventeenth-century yew, a moat and gun battery. The castle and limestone quarry can be reached along the canal's Spring Branch from Belmont Wharf.

It is an interesting, though not surprising coincidence that in the same year, a young Andrew Hemmings had his picnic lunch in the grounds of Skipton Castle. Andrew was on a school trip from Roseacre Primary School, Blackpool to York.

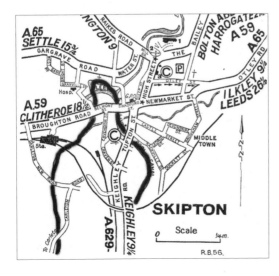

Map of Skipton.

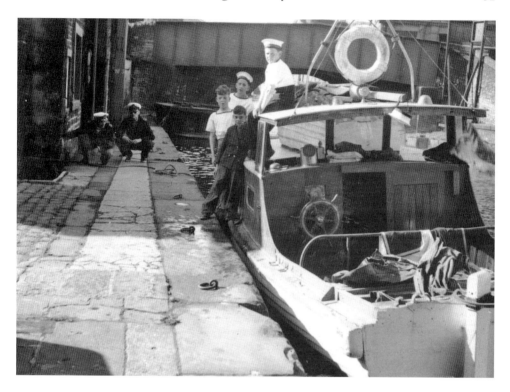

Above: Taking on water.

Right: Captain Robin Osborne at Pennine Boats, Skipton, 2011.

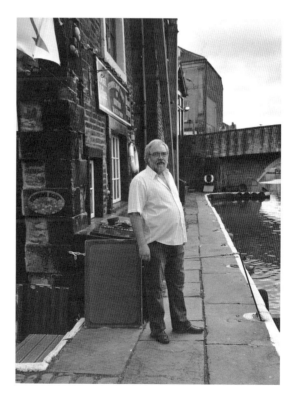

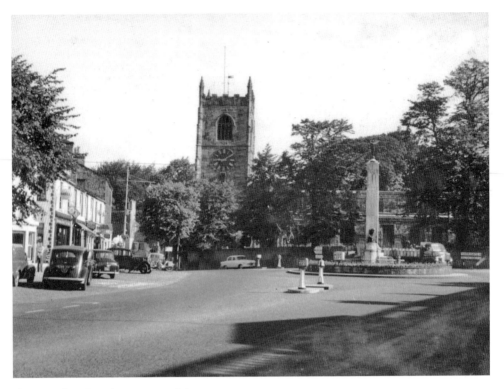

Skipton Church and war memorial.

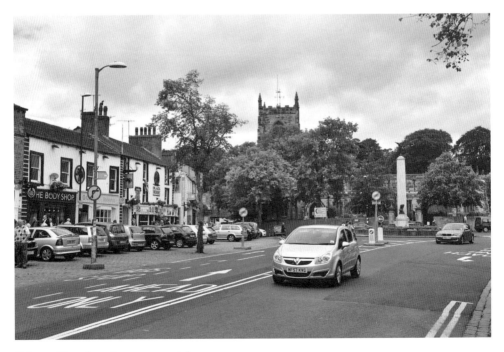

Skipton Church and war memorial, 2011.

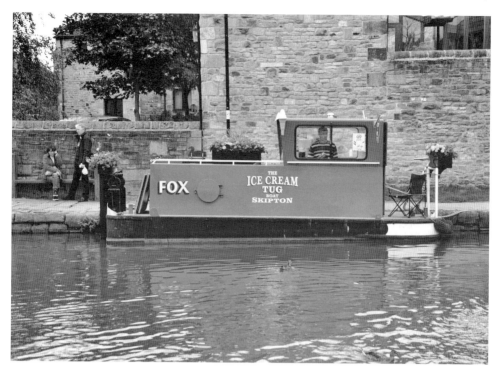

Ice Cream Tug, Skipton, 2011.

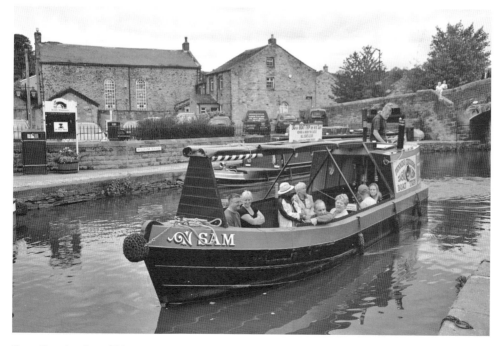

Sam, Pennine Boat Trips, 2011.

4

SKIPTON TO LEEDS

Bingley

The *AA Road Book* of 1958 says that Bingley is 'a manufacturing town in the Aire Valley, with a moorland tract to the north'.

The cadets had to descend both the Five Rise and Three Rise Locks on their eastward journey.

From the photographs it appears that TS *Queenborough* entered the first lock and the cadets then tried to empty the full chamber of that lock into another full chamber below. The consequences of flooded towpath and stranded cadets are obvious.

In 2011 the leisure craft enjoy a more measured descent under the watchful eye and tutelage of Head Lock Keeper Barry Whitelock MBE. Barry has been in post since 1978 and played a major part in reducing the risk of flooding from the Leeds & Liverpool Canal in 2002. Thanks to his knowledge and foresight in ordering the opening of gate paddles all the way to Leeds, the build-up of storm water was safely released from the canal into the River Aire below Leeds. Barry was subsequently awarded an MBE for his services. Our picture in 2011 shows John Norris descending the locks at the helm of his narrow boat *Kestrel*.

Taking the canal down by a height of 60 feet, the Bingley Five Rise is fully deserving of its position as one of the Wonders of the Waterways World. The locks, in a staircase formation, were opened in 1774 amid much local excitement and celebration. Modern-day instructions state that 'descending and ascending the staircase is only possible with the assistance of the resident lock-keeper'. This assistance was not available to the Sea Cadets crew in 1958.

They also descended the Bingley Three Rise Locks where we talked to John Lobley, British Waterways seasonal lock-keeper. He stood ready to help twenty-first-century leisure boaters through the Grade II-listed locks. In 1994 part of this section close to the Damart Mill Chimney had to be diverted to accommodate the construction of the new by-pass.

Also in the environs of Bingley Five Rise is Hainsworth's Boatyard, where the jumble of boats and buildings appealed to photographers in 1958 and 2011. Our pictures show a boat on the water with the intriguing outline of a large Nissen hut in the background.

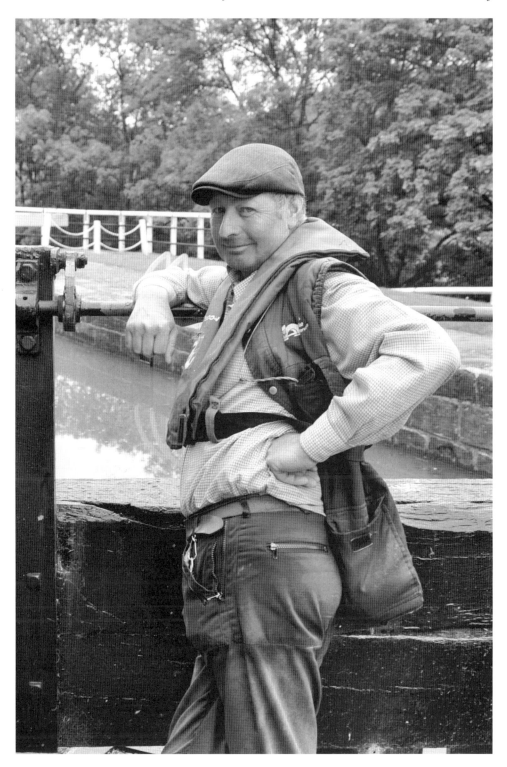

Barry Whitelock MBE, 2011.

Left: Bingley Five Rise Top Lock.

Below: Kestrel, 2011.

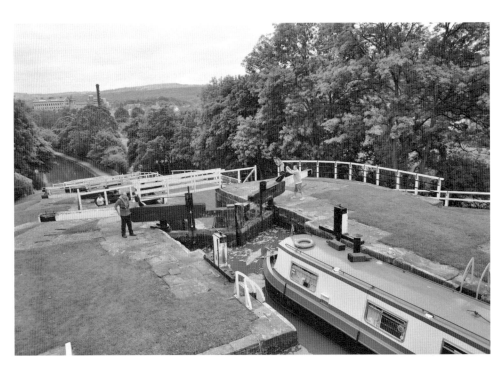

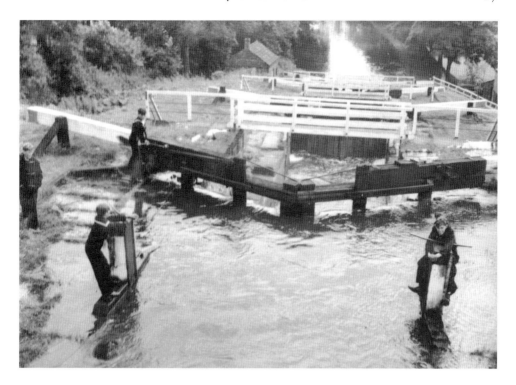

Above: Flooding the lock.

Right: Filling the lock, 2011.

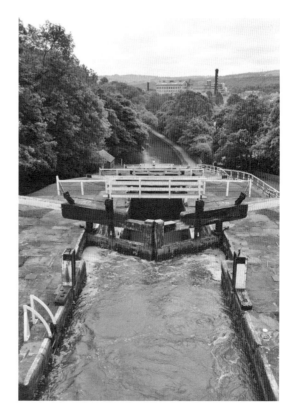

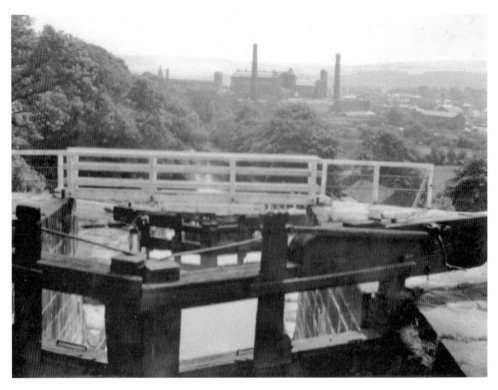

Bingley Top Lock.

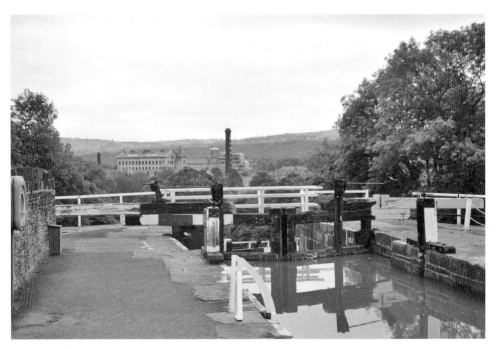

Bingley Top Lock and Damart Mill, 2011.

Right: John Lobley.

Below: Bingley Three Rise – new road, 2011.

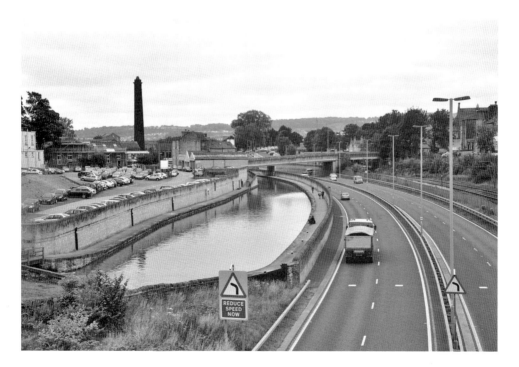

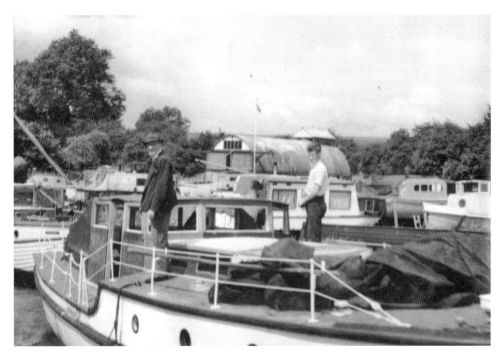

Hainsworth's Boatyard, 1958.

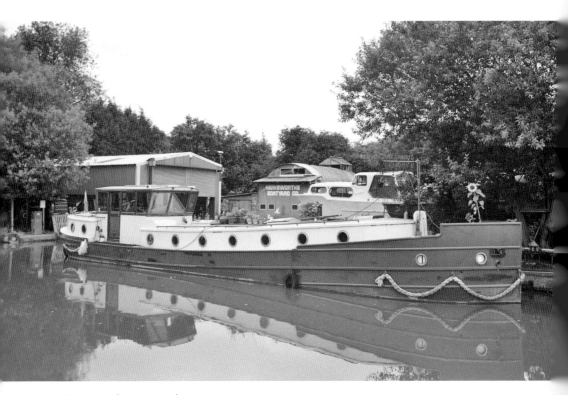

Hainsworth's Boatyard, 2011.

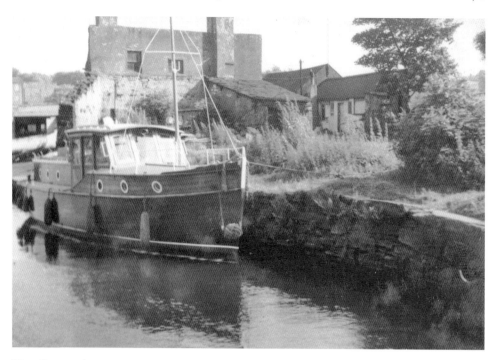

Near Boatyard, 1958.

Near Boatyard, 2011.

Saltaire

Alf Firby showed a keen eye for a landscape shot with his long-distance view of Saltaire, now designated a World Heritage Site by UNESCO. The canal goes through the village and mills, famously named after Sir Titus Salt. Between 1851 and 1876 he built the textile mill (Salts Mill), and this village on the River Aire to accommodate his workforce.

As described in the 2011 official guide:

Saltaire's Architecture

Saltaire's architecture is stunning and in an Italianate style. There are some unique public buildings, including a church [now the United Reformed Church], school [now used by Shipley College] the Victoria Hall [where concerts and other events take place, including weddings] a hospital [now converted into flats] and some almshouses, which are people's homes. The village houses are privately owned and we were free to wander the streets, though peeping through people's windows is not appreciated.

The Houses in Saltaire Village

The houses were built in different styles for different levels of worker. This is a working and residential village, complete with traffic flow, and there aren't many direction signs or notices. For some people this is part of its charm – for others it's very frustrating!

Roberts Park

Roberts Park was restored with a Heritage Lottery Grant and the work was completed in 2010. Beneath the statue of Sir Titus Salt you'll see the Half Moon Café which has been restored and now opens regularly throughout the week and at weekends.

We enjoyed a pleasant al fresco lunch at the café during our stop in Saltaire.

Sir Titus Salt deliberately sited his mohair and alpaca mill next to the Leeds & Liverpool Canal to distribute his woollen products quickly and cheaply. Canal boats also could bring in supplies of the raw material, wool and coal.

During our 2011 visit we witnessed a very different sort of cargo as depicted in this picture of the 'Ice Cream Barge'.

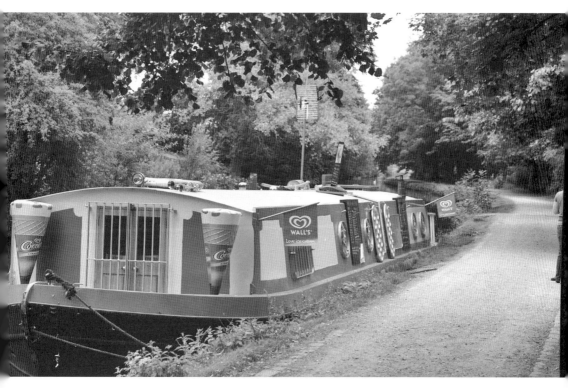

Ice Cream Barge, 2011.

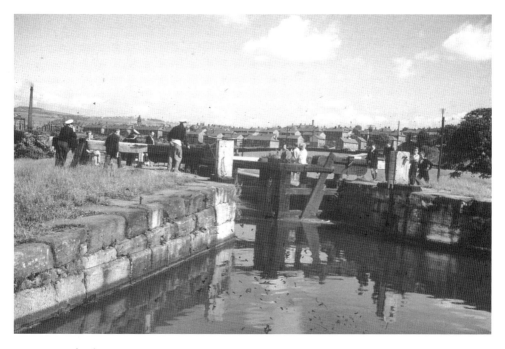

First view of Saltaire.

Saltaire washing line.

Mill, Saltaire, 2011.

Hospital, Saltaire, 2011.

Leeds

Even after the urban settings of Wigan, Blackburn and Burnley, Leeds can come as a shock to the modern canal traveller. In 1958 it was regarded as an important university and manufacturing city on the River Aire, noted for fabrics, footwear and engineering products. In recent years Leeds Waterfront has undergone a transformation that is clearly evident from the 2011 photographs.

Many of the once derelict and disused warehouses and arches have been turned into attractive shops, restaurants and offices. The cityscape is further enhanced by new buildings such as the round tower apartment block, the Mint Hotel, Granary Wharf and revitalised railway station.

Leeds itself is a significant site on Britain's waterways as it marks the junction at River Lock of the Leeds & Liverpool Canal with the fast-flowing River Aire and subsequent Aire & Calder Navigation. It also marked the Sea Cadets' venture into swimming. When they were in Leeds the cadets were lined up on the boat and told to dive in. Ben Lynch remembers that 'it was the coldest water ever; they dived in and dived out'. Fortunately all the cadets were good, competent swimmers. Throughout the whole trip there was only one instance of 'Man Overboard!' and he was quickly pulled out. This may well have been the occasion recalled by Ben when 'young Firby tried to walk up the rope holding the boat to the shore and he fell in'.

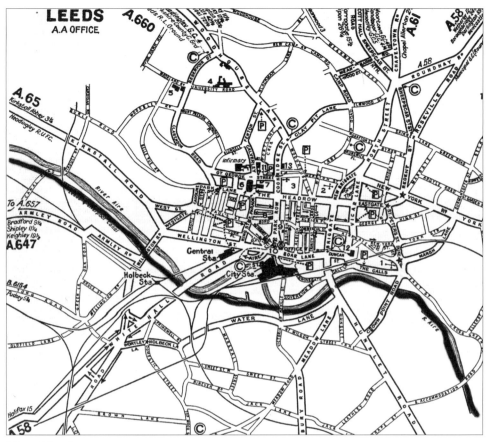

Map of Leeds.

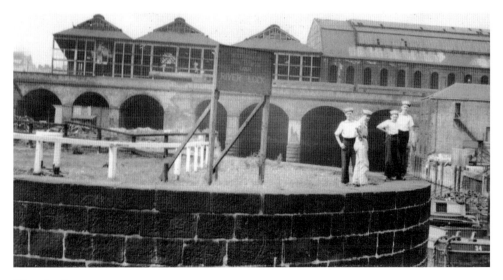

River Lock.

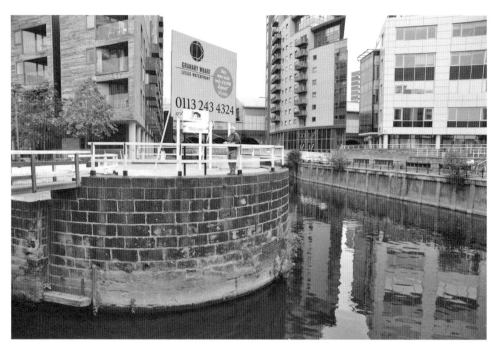

Granary Wharf at River Lock, 2011.

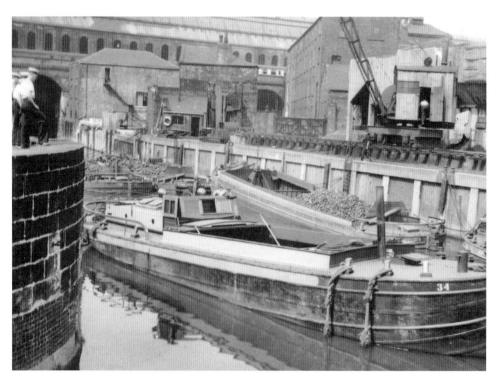

Coal Wharf.

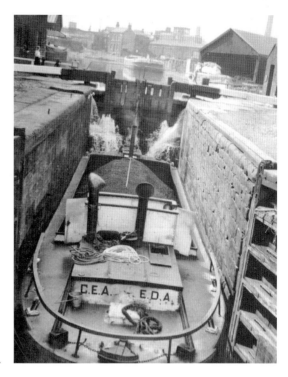

Coal barge in lock.

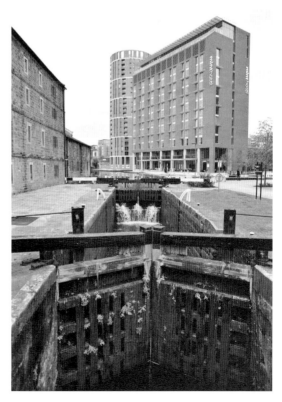

The Mint Hotel, 2011.

River Aire – site of coal wharf, 2011.

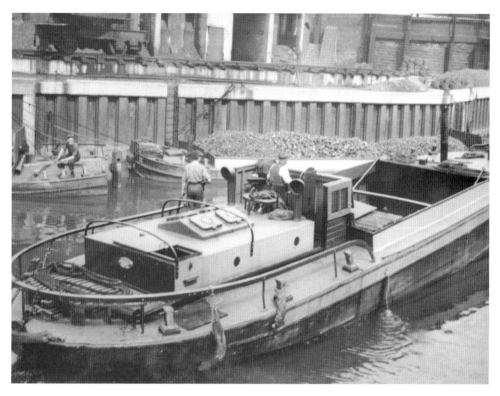

Coal wharf.

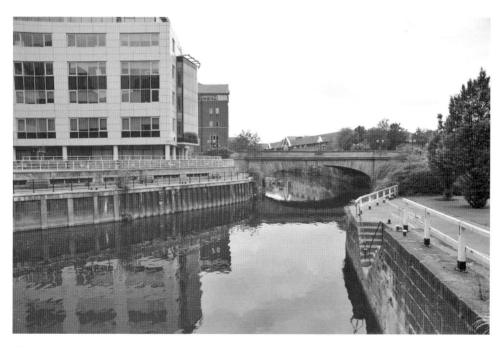

River Aire – leaving Leeds, 2011.

5

CASTLEFORD, GOOLE AND THE HUMBER

Castleford and Whitley Bridge

As there was no suitable camping site in Leeds, TS *Queenborough* made good progress towards Whitley Bridge. Our visit in 2011 shows the Old and New Bridges together with the moorings for the Jolly Miller. On the advice of the Commercial Boat Owners Association (CBOA) we went to Castleford Junction Lock to ask the lock-keeper about commercial traffic on the Aire & Calder Navigation. Unfortunately we had missed the only working boat of the day, but were able to see suitable examples at the Waterways Museum in Goole.

We were fortunate to meet up with Steve Jones, owner and captain of *Muddy Waters*. Designed as ocean-going, this vessel could fit in the locks on the Leeds & Liverpool Canal and was capable of sailing from Hull to Liverpool. Our 2011 photographs show a substantial vessel, built by D. B. Marine of Knottingley, 58 feet long and 12 feet wide with a draught of 2 feet 6 inches. This compares with the 32-foot-long cutter, TS *Queenborough*, also with a draught of 2 feet 6 inches.

According to the builder's specification, *Muddy Waters* is built for extended voyages where conditions may exceed wind force 8 (Beaufort scale) and significant wave heights of 4 metres (approximately 12 feet) and above but excluding abnormal conditions. Vessels are largely self-sufficient.

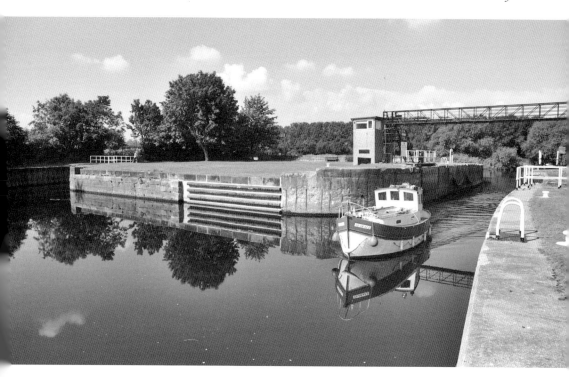

Above: Castleford Lock, 2011.

Right: Water level indicator.

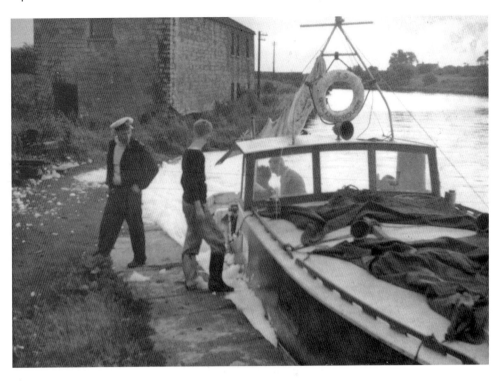

Above: Aire & Calder Navigation.

Left: Muddy Waters, 2011.

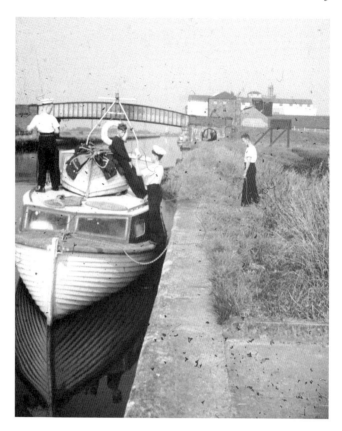

Right: Whitley Bridge.

Below: Whitley Bridge, 2011.

Goole

As might be expected, Goole Docks have changed markedly over the past fifty years. The *AA Road Book* for 1958 states that Goole stands at the confluence of the Rivers Ouse and Don, with extensive docks, and a water tower said to be the largest in England. In 2011 we made our way to the Yorkshire Waterways Museum. This gives the canal's history, offering a café and boat trips aboard the *Telethon Louise*. We took advantage of the boat trip to view the docks from the water, starting with the British Waterways depot and the old timber ponds used for moorings. The boatmen thought that TS *Queenborough* may have tied up there for the overnight stay whilst awaiting the arrival of Hull Sea Cadets Corps boat. We also noted the *Wheldale* push tug with a 'jebus' false bow from the Tom Pudding trains and two examples of compartment tubs from the latter. In 1958 the tugs and Tom Pudding trains were alive and well carrying coal on the Aire & Calder Navigation. In June 2012, *Wheldale* took part in the Queen's Diamond Jubilee pageant on the River Thames.

Goole Docks were created in 1828 for the canal to export coal and textiles and it is Britain's premier inland port. In spite of being more than 50 miles from the sea there are strong trade links with the Baltic and other parts of Europe. By the twenty-first century, nine docks offer around 3 miles of quays, silos, a container terminal and a steel terminal with canopy.

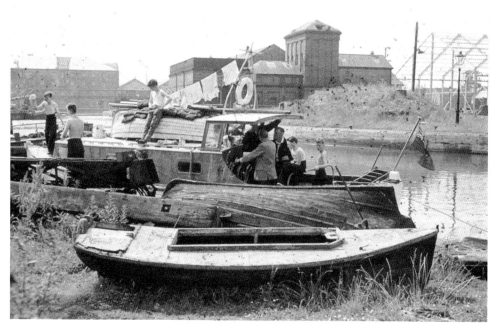

Goole Docks.

Goole Docks, 2011.

Singularity at Goole.

RMS *Riga*, 2011.

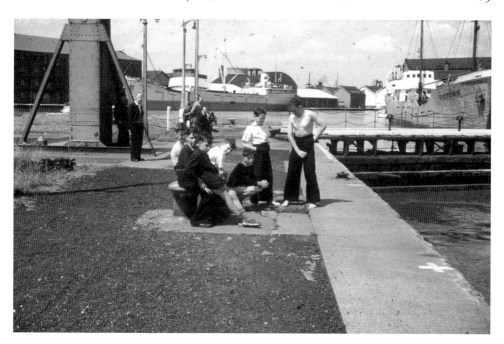

Above: Cadets at Goole Docks.

Right: Trans Frej at Goole Docks, 2011.

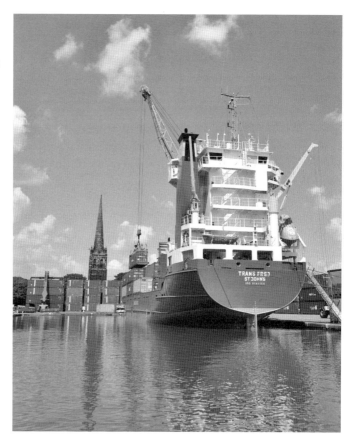

The Humber

On Saturday 27 July 1958 the Training Ships *Revenge* and *Queenborough* set sail through Ocean Locks, Goole across the Humber to Hull. TS *Revenge* was a naval pinnace belonging to Hull Sea Cadet Corps whose crew had crossed the Humber to escort TS *Queenborough* to Hull. Again Alf Firby was on deck to photograph both boats and other shipping in the Humber Estuary. From research we have identified these as MV *Concentricity* and MV *Singularity*. The latter featured in the Royal Naval Coronation Review in June 1953.

During the crossing, TS *Revenge* sent a message in Morse code by Aldis lamp to TS *Queenborough*. Ben Lynch was the signaller on duty on TS *Queenborough* and he was rather surprised to receive any message. Undaunted, he replied in Morse code, 'Old shoes are easiest'. On landing in Hull, his counterpart admitted himself rather baffled by the reply and thought it must be further encrypted. Ben has now admitted it was the only message in Morse that he knew.

In 2011 it was not possible for us to set sail across the Humber Estuary. We contented ourselves with making for its northern shore and the best viewpoint of the Humber Bridge which opened in 1981. Our nautical theme was well maintained when the MV *Lady Mary* sailed upstream going from Immingham to Hull and Goole. At 3,550 tonnes, she was built in 2008 to carry dry cargo and is registered in St John's, Antigua. By way of comparison, the MV *Singularity* built in 1952 is 1,566 tonnes, and is possibly still sailing the Adriatic renamed *Asya Anc* under the Turkish flag out of Istanbul.

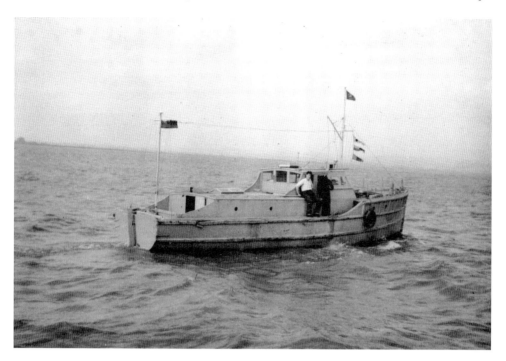

Above: Hull SCC boat.

Right: Aldis lamp.

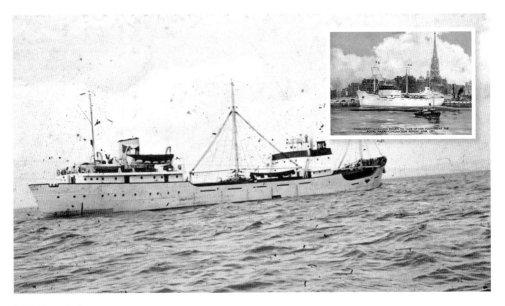

MV *Singularity.*

Inset: MV *Singularity* at Coronation Review, 1953.

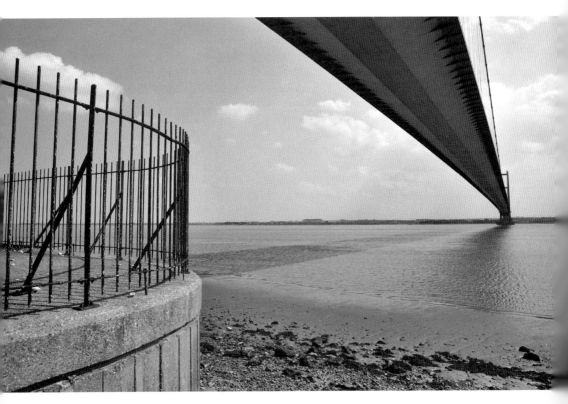

Humber Bridge, 2011.

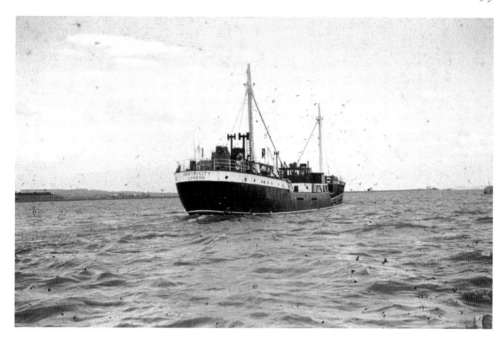

MV *Concentricity*, 1958.

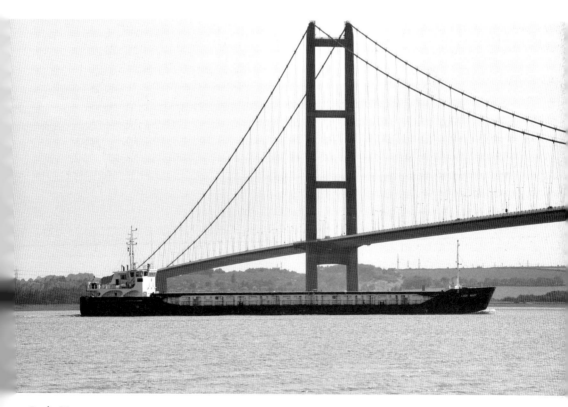

Lady Mary, 2011.

6

HULL

Known officially as Kingston upon Hull, this was an important fishing port in 1958 with extensive docks on the River Hull where it flows into the Humber. A key landmark was Holy Trinity Church, one of the largest parish churches in England and noted for its early brickwork and tower. The *AA Road Book* drew attention to the Wilberforce House and Museum, the bomb damage inflicted during the war and the car ferry connecting with New Holland. Nowadays the ferry service has long gone having been replaced by the Humber Bridge.

The Captain's Log for 1958 mentions that the Lytham Sea Cadets stayed the night of Saturday 26 July at Hull using Hull Sea Cadet Corps' boat for sleeping quarters. The following day they were met by Hull SCC Leading Cadet and taken to attend Divisions at Hull SCC Headquarters. They toured the headquarters before leaving Hull during the afternoon for the homeward journey.

Our 2011 foray to Hull begins with thanks and an apology. We received a very warm welcome from the present-day Committee of the Sea Cadets Corps at their headquarters TS *Iron Duke*, Argyle Street. Thanks are due to CO Jacqui Gorman, Susan Coupland and Vic Chandler BEM for his recollections. We are particularly grateful to Susan Coupland for her research into West Parade Headquarters and her assistance during our visit. Following extensive research in the Sea Cadet Corps records we conclude that it is probable that the TS *Queenborough* and TS *Revenge* were berthed in Victoria Dock, Hull.

Alf Firby's photographs provide an excellent pictorial narrative of the Lytham Sea Cadets' time in Hull. They begin with Ben Lynch on the ladder from Hull Sea Cadets' boat, the ensuing inspection on the quayside, before the crew walked from the boats to Hull Sea Cadets Corps Headquarters at West Parade. Also seen is a member of Hull Sea Cadets Corps who cycled over to meet and escort them. One photograph shows a street scene on Anlaby Road with the Continental Palace (formerly Music Hall) in the middle distance.

The next set of 1958 pictures shows Hull SCC including non-uniformed new joiners, and the Marine detachment on parade at West Parade. Officers of Hull SCC are in evidence with Victor Chandler on the right and CO Lt Cdr Barling walking away from the camera.

In 1958, the headquarters of the Hull Sea Cadets was at No. 8 West Parade. West Parade itself was home to many Hull merchants and dignitaries with Sir William Alfred Gelder residing at No. 8 West Parade House. This was a magnificent building already shown in Alf Firby's photographs of 1958. By 1964 the site was the subject of a Compulsory Purchase Order and cleared for the construction of the Hull Royal Infirmary. Guided by Susan Coupland we went to the location of West Parade House, which is now surrounded by the multitude of buildings that make up this major hospital complex. The entrance to West Parade was absorbed into the hospital site. Its course ran through the Women's Hospital and past the present-day Alderson House. To the left of the Women's Hospital is the present Wilson Building, formerly a car showroom. Parading on Anlaby Road, the cadets would have turned into West Parade with the garage on their left.

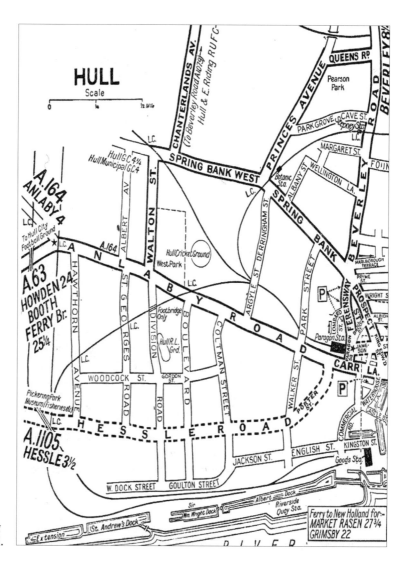

Left and following page: Map of Hull.

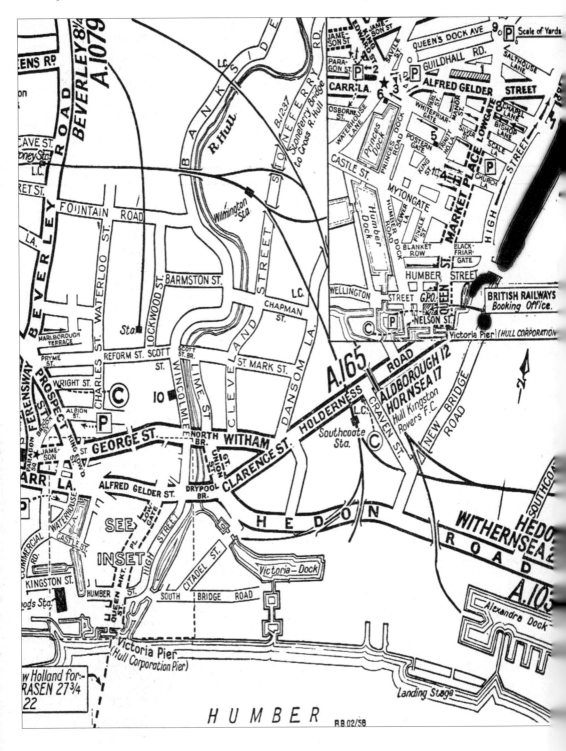

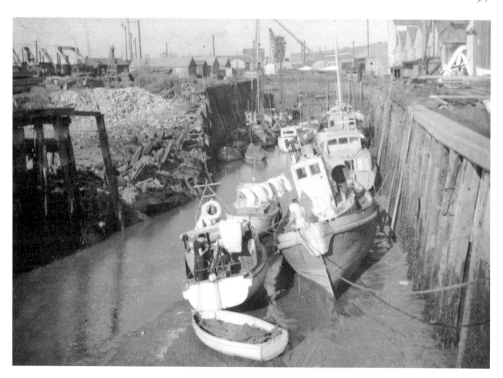

TS *Queenborough* and TS *Revenge* probably in Victoria Dock.

Reclaimed land – site of dock basin, 2011.

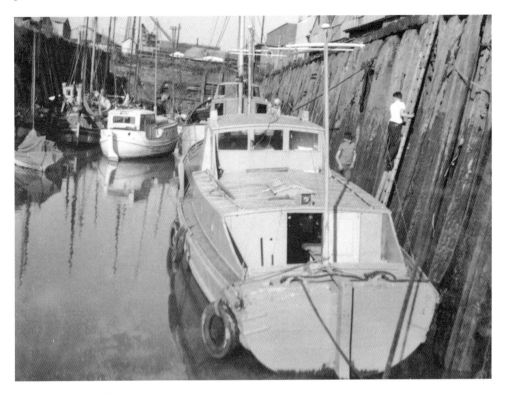

Ben Lynch on ladder.

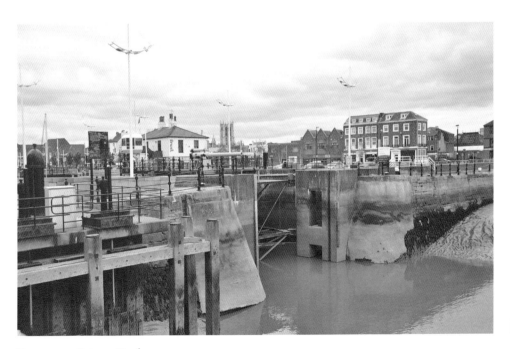

Entrance to Princes Dock, 2011.

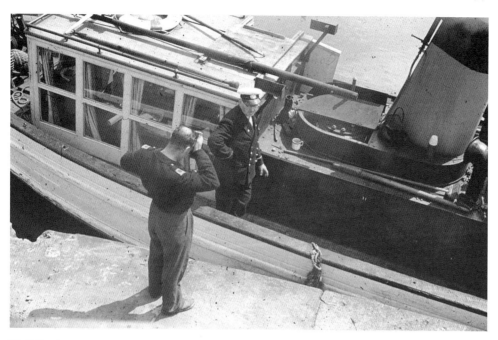

Hull Docks.

Marina quayside, 2011.

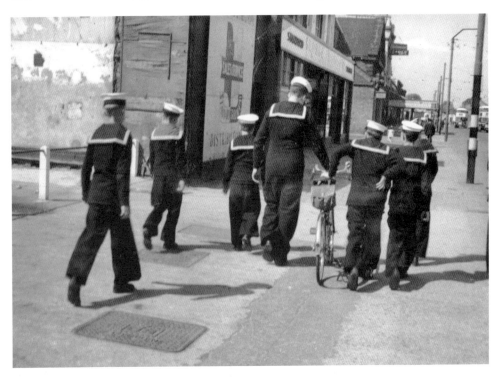

Anlaby Road.

Car showroom, now Wilson Building, 2011.

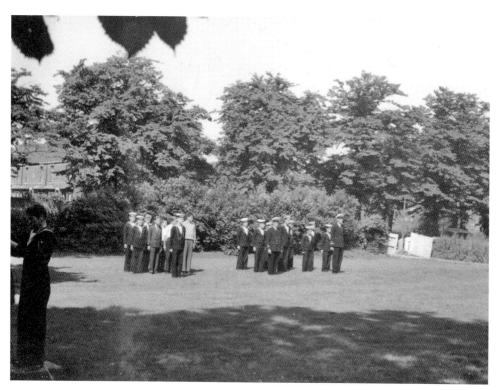

Lytham SCC detachment.

Quarterdeck TS *Iron Duke*, 2011.

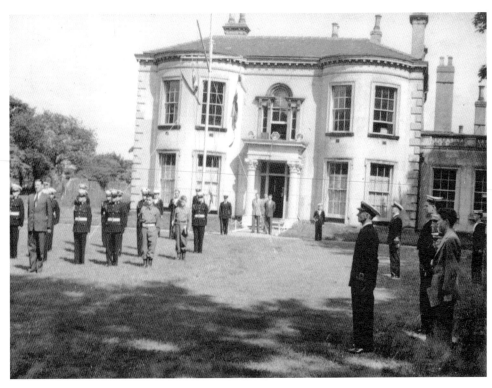

Marine Corps – West Parade House.

Pennant, 1958.

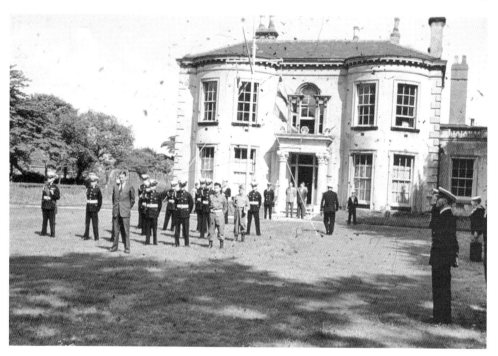

Parade at West Parade HQ.

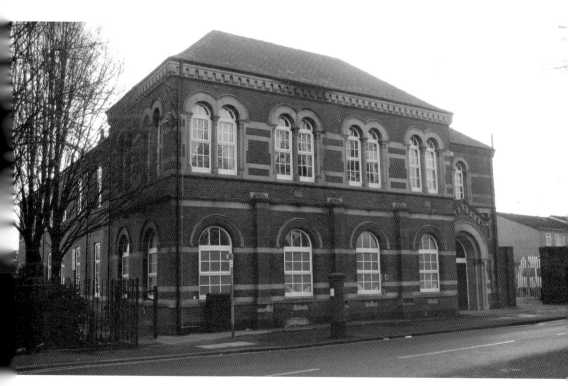

TS *Iron Duke*, Hull SCC, 2011.

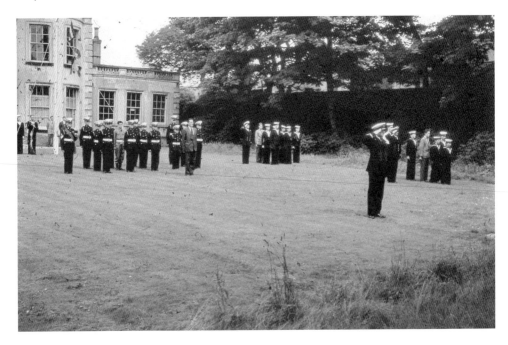

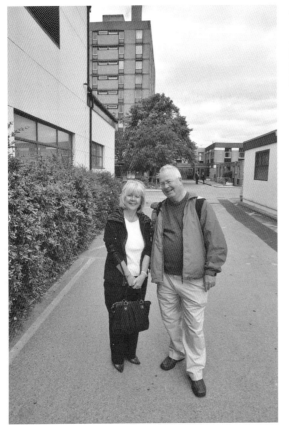

Above: Taking the salute.

Left: Sue Coupland and Andrew Hemmings, site of West Parade, Hull Royal Infirmary, with Alderson House in the background, 2011.

The Deep Aquarium, Hull, 2011.

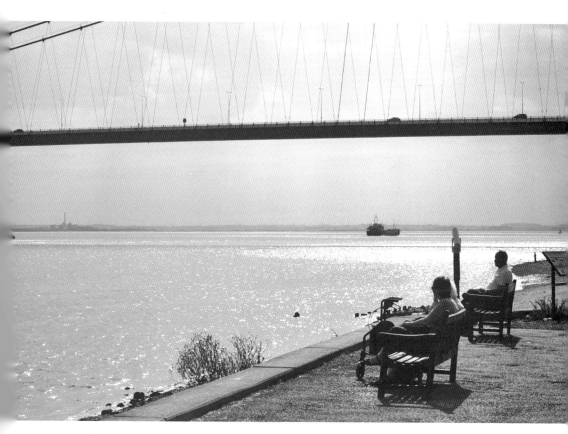

Leaving Hull, 2011.

7
RETURN JOURNEY

Hull to Apperley Bridge

On Sunday 27 July TS *Queenborough* made a prompt unescorted start from Hull, catching the tide to sail up the Humber and River Ouse to Goole. In 2011, the Tom Pudding coal wagon tippler was spotted, virtually unchanged since 1865 and in operation until 1986. This was one of the four used on land and was accompanied by another floating one. Hydraulic rams in pepper-pots at the top tilted the Tom Pudding compartments through 125° to empty the coal.

At Goole, TS *Queenborough* was refuelled and took on water before embarking for Whitley Bridge. As on the outward journey, the cadets camped here, on a route then characterised by a predominance of commercial boat traffic on the Aire & Calder Navigation. In 2011 there are new bridges for both the A19 road and M62 motorway.

Alf Firby's photographs capture the essence of Navigation traffic in 1958 showing TS *Queenborough* in a lock with working Tug No. 18 and its accompanying jebus, hauling the Tom Pudding trains. Alf also photographed the compartment tubs as well as TS *Queenborough* in a lock with a working barge. Whilst there are still some working barges on the Aire & Calder Navigation in 2011, the push tugs, jebus false bows and Tom Pudding compartment tubs are only to be found at the waterways museum.

From the 1860s until 1986 there were Tom Puddings on the Aire & Calder Navigation. These 40-ton compartment boats were used to carry coal, and were usually towed in 'trains' of nineteen to be lifted and tipped into ships at Goole. On Monday 28 July TS *Queenborough* left Whitley Bridge, travelling through Castleford and Leeds to the camp-site at Apperley Bridge. Castleford, a manufacturing town on the River Aire, is notable for the water crossroads at Castleford Junction Lock. There is a direction board and batteries of traffic lights pointing in all directions. The cadets would have experienced again River Lock where the Aire & Calder Navigation joins the Leeds & Liverpool Canal. The River Aire emerges from the Dark Arches beneath the railway station. These are a series of long parallel tunnels where the water flows fast with the occasional small fall, the tunnels not being straight and some having complicated exit routes. A roadway and foot-way ran across the insides of the tunnels at high level, parallel to the railway.

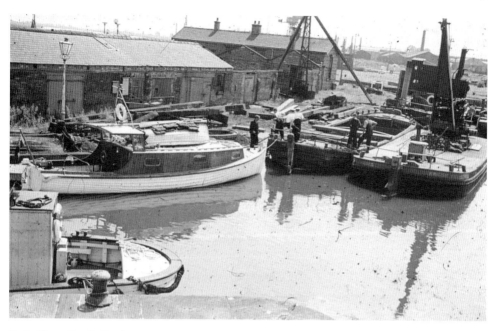

Refuelling, Goole Dock.

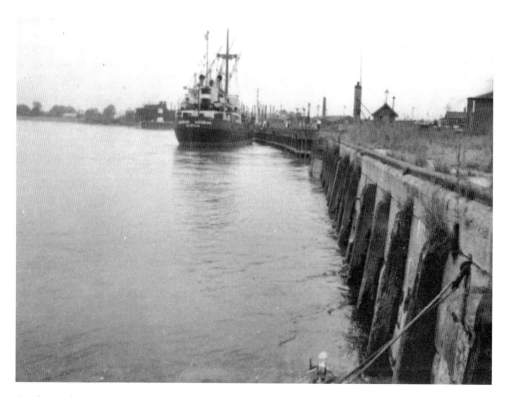

Goole Dock.

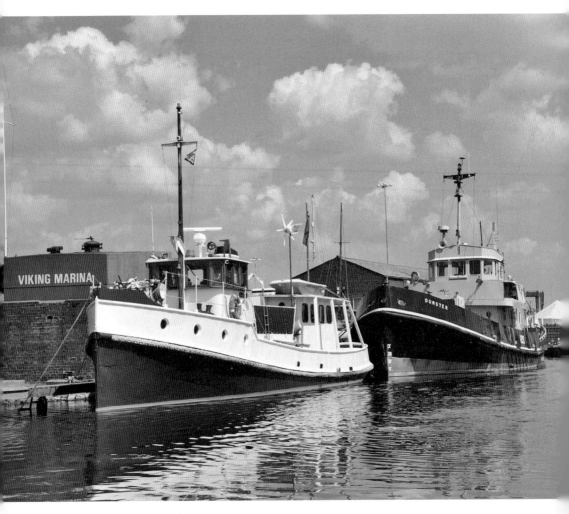

Tug *Dunster*, Goole Docks, 2011.

TS *Queenborough*.

Heather Rose, Aire & Calder Navigation, 2011.

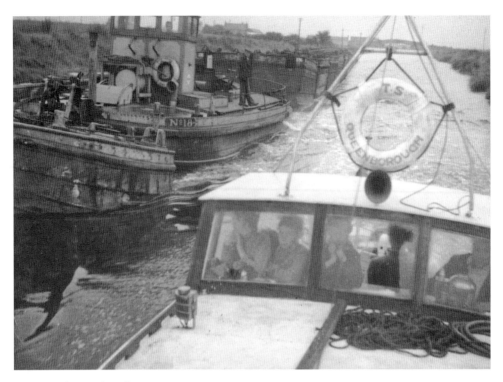

TS *Queenborough* and Tug.

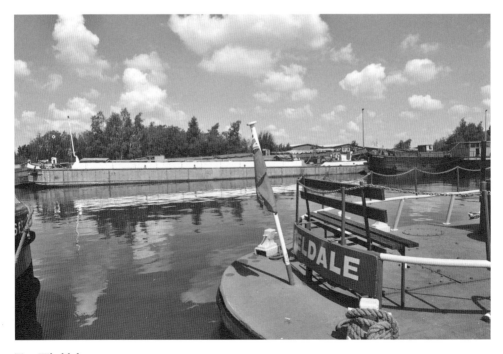

Tug *Wheldale*, 2011.

Tom Pudding trains.

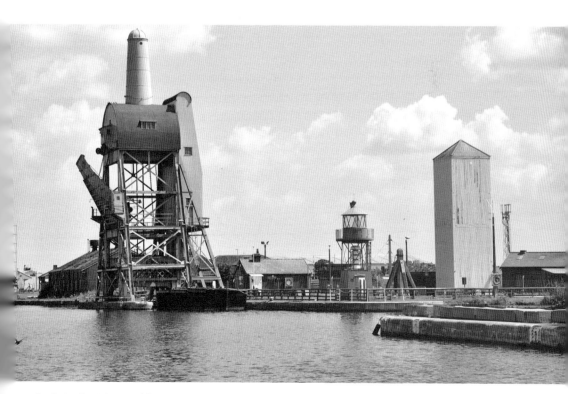

Coal tippler, Tom Pudding compartment, 2011.

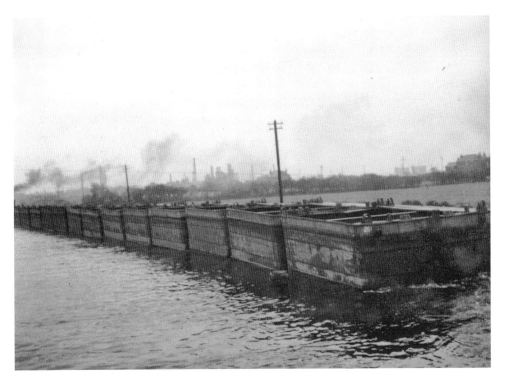

Tom Pudding train.

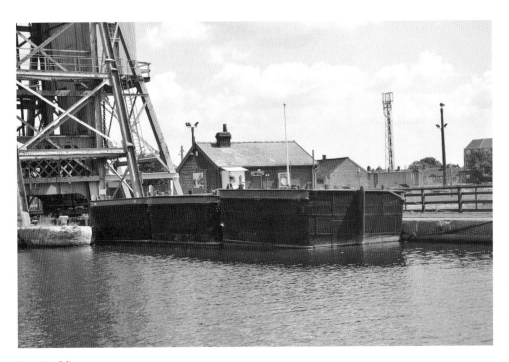

Tom Pudding compartments, 2011.

Right: TS *Queenborough* sharing a lock with a working barge.

Below: Humber Renown, Aire & Calder Navigation, 2011.

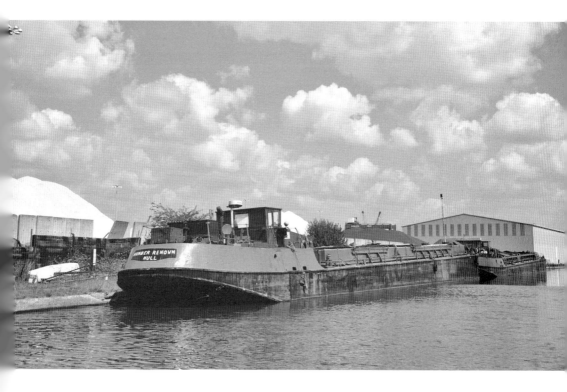

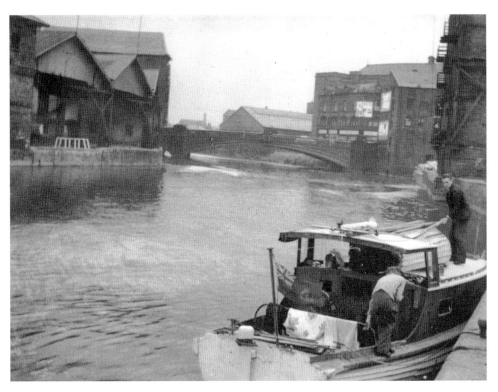

TS *Queenborough*, Leeds.

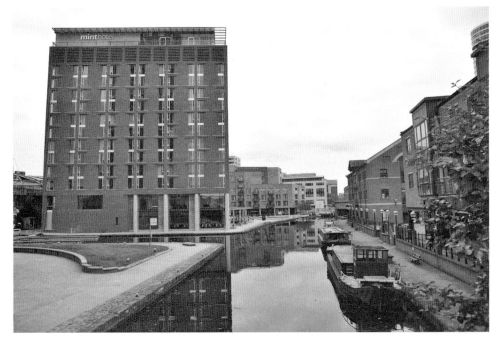

The Mint Hotel, Leeds, 2011.

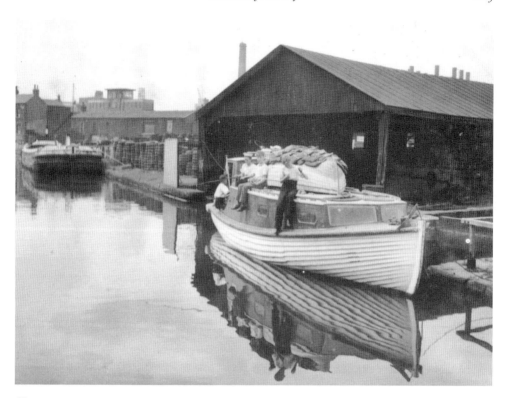

Cityscape.

Office Lock, 2011.

Apperley Bridge to Skipton

On Tuesday 29 July the journey continued from Apperley Bridge to Skipton with the cadets staying the night at Skipton. This meant an ascent of Bingley Three Rise and Five Rise Locks and a visit to The Fleece Inn. Alf Firby has illustrated these with Lt Terry Blackledge surveying the scene from the entrance to The Fleece. He and the other officers provided a good supply of lemonade and crisps for the young cadets whilst taking a break from the task of commanding TS *Queenborough*. Further photographs show the leisure craft moored by Hainsworth's Boatyard at Bingley as well as a working barge *en route* to Skipton. Perhaps subconsciously Alf was recording both the past and future of canals during this one day in July 1958. The stop at Skipton is recorded in the scenes of the church and statue from 1958 and 2011. Skipton is one of Yorkshire's oldest market towns, with a market most days in the Georgian High Street. The Black Horse Hotel hosted the first canal company meeting in 1770.

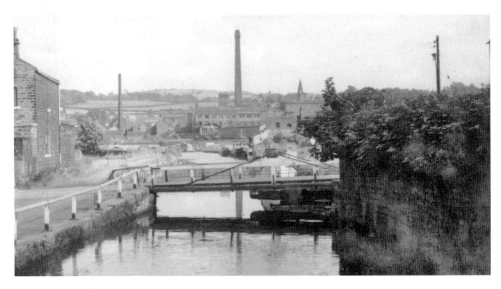

Leeds to Apperley Bridge.

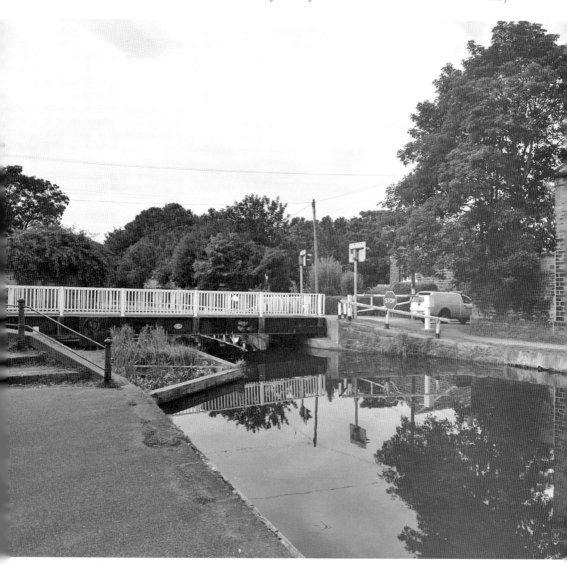

Hillman Swing Bridge, 2011.

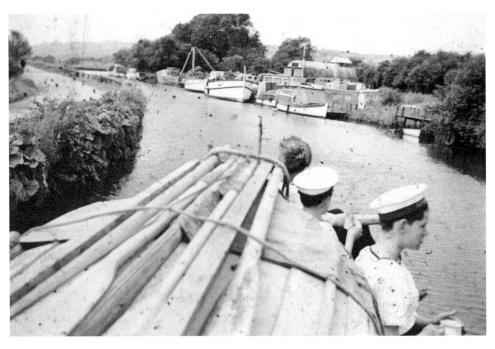

Leisure craft, 1958.

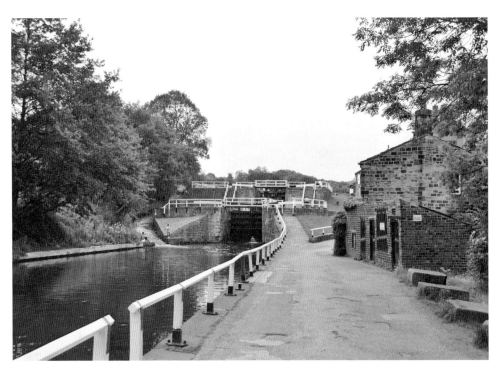

Dobson Two Rise Locks Nos 15–14, 2011.

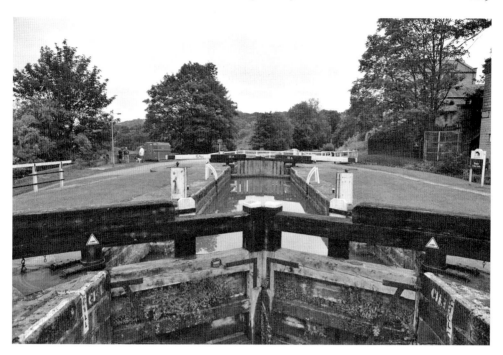

Bingley Three Rise Locks, 2011.

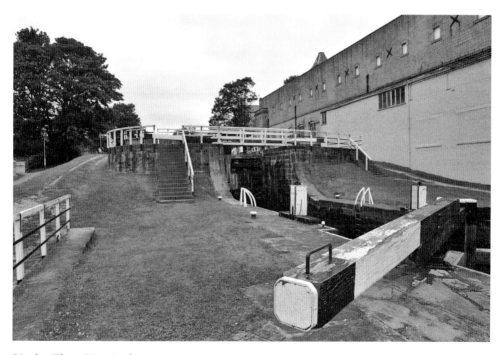

Bingley Three Rise Locks, 2011.

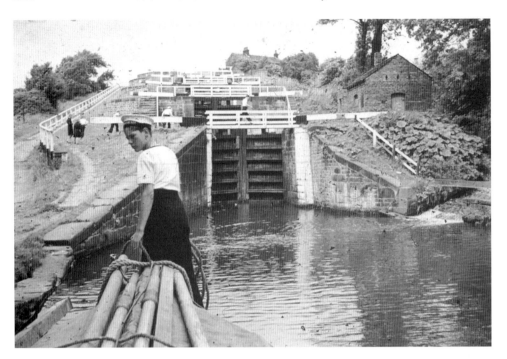

Bingley Five Rise Locks.

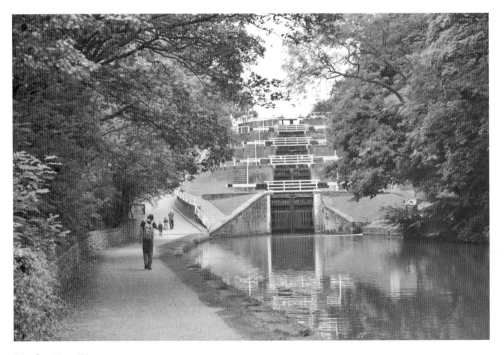

Bingley Five Rise, 2011.

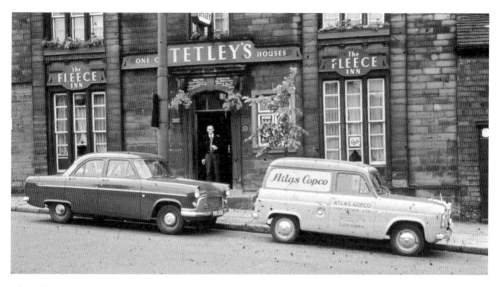

The Fleece Inn, 1958.

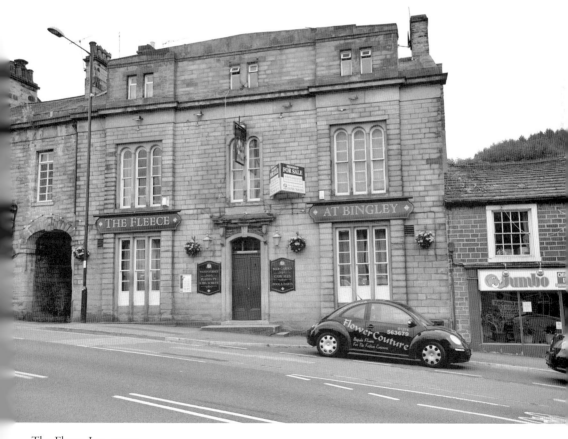

The Fleece Inn, 2011.

Skipton to Tarleton

The final set of photographs in 1958 show tranquil, pastoral scenes in the Aire Valley. There were no further pictures illustrating the long haul from Skipton to Tarleton in the four days from Wednesday 30 July to Saturday 2 August. The Captain's Log records camping stops at Barrowford, Clayton-le-Moors and Apperley Bridge. Ben Lynch recalls that they made good time, sleeping on the boat on rainy days and operating the locks efficiently with the minimum of fuss. Once, on the return trip, everyone slept under the arches of a viaduct, warm and most comfortable as Ben remembers it. Each cadet had his allocated position and tasks, fore and aft on the boat, rope handling and gate opening on the lock side. However, the Log records that this progress was not enough to reach Tarleton Lock in time to catch the tide across the Ribble Estuary. In the event, the crew had to tie up TS *Queenborough* at Tarleton and return via Preston to Lytham by train from the railway station at Hesketh Bank and Tarleton. A young Andrew Hemmings may well have been trainspotting on Preston Station on that day in 1958, as the detachment of Sea Cadets arrived on the service from Southport and changed to the train for Lytham. It is ironic that this is the only part of the trip that cannot be re-enacted in 2011. The railway line from Preston to Southport (St Lukes) closed on 7 September 1964, although Hesketh Bank Station enjoys steam engines again in the shape of the West Lancashire Light Railway with its 2-foot gauge layout.

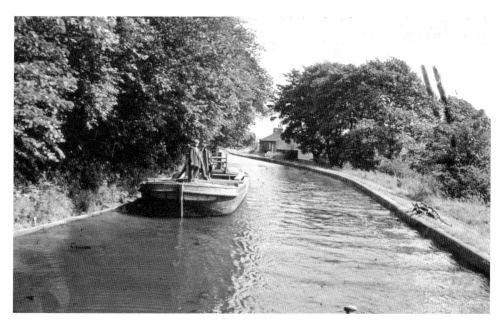

Working barge.

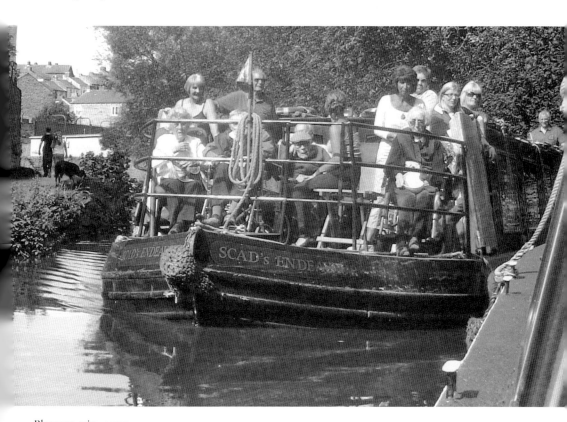

Pleasure trip, 2011.

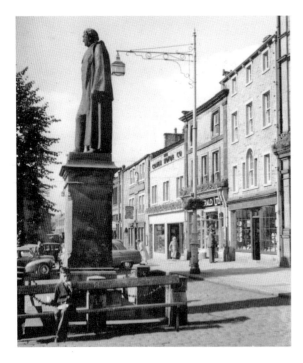

Statue, 1958.

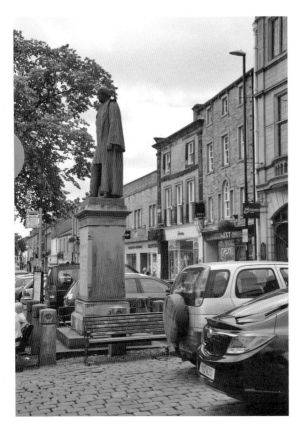

Statue, 2011.

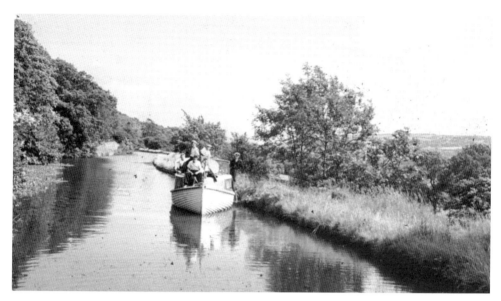

Canal scene, 1958.

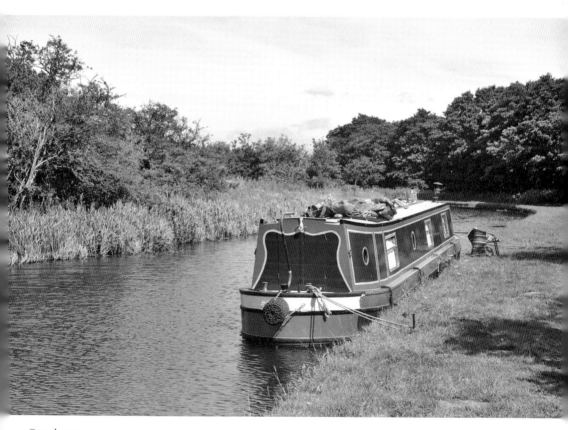

Canal scene, 2011.

POSTSCRIPT

The officers of Lytham Sea Cadet Corps were obviously in touch with their opposite numbers at Hull Sea Cadet Corps before the visit. Afterwards contact was lost as officers left the Corps. Overall the Sea Cadets imparted a good sense of confidence and comradeship as Ben Lynch embarked on his joinery apprenticeship. He remained in contact with the other lads who also became tradesmen locally in Lytham and St Annes. He sums it up by saying 'it was a practical time for practical lads'.

During our researches and travels for this book we were constantly asked if it is possible to make the journey again in the twenty-first century. The answer is a qualified 'Yes' according to Steve Jones of *Muddy Waters*, whom we met at Castleford Lock. Steve's boat is ocean-going with the dimension to fit the locks on the Leeds & Liverpool Canal. He would need to drop the wheelhouse to get under some low bridges and have sufficient depth of water under the keel when crossing the Summit. Our journey in 2011 showed that the infrastructure, lock-keepers and facilities are in place but it does need the right sort of boat, skipper and crew.

It is a tribute to the memory, vision and leadership of Lt Terry Blackledge and to the commitment and skill of his daughter, Judith Eastwood, that Lytham Sea Cadets Corps carried out a partial re-enactment of the voyage in 1988. Using kayaks and a small support boat, they made the journey from Lytham to Skipton, much as their predecessors had done in 1957 and 1958.

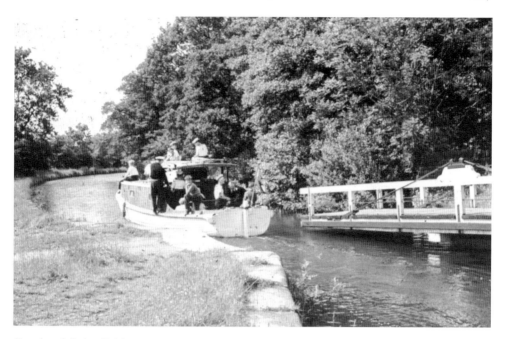

Canal and Swing Bridge.

Canal scene, 2011.

BIBLIOGRAPHY

As with our Acknowledgements, this book would not have been possible without the considerable volume of reference material provided by knowledgeable authors and committed publishers. In particular the maps have been reproduced from 1958 Ordnance Survey maps with the kind permission of Ordnance Survey.

AA's Illustrated Road Book of England and Wales (c. 1964).
Anlaby Road [online] www.anlabyroad.com (2011).
Buchanan, R. A., *Industrial Archaeology in Britain* (Penguin, 1972).
Chaplin, Tom, *Narrow Boats* (Whittet Books, 1989).
Clarke, Mike, *The Aire and Calder Navigation* (Tempus, 1999).
Clarke, Mike, *The Leeds & Liverpool Canal* (Carnegie Press, 1990).
Corble, Nick, *Britain's Canals* (Amberley Publishing, 2010).
Crabtee, Harold, *Railway on the Water* (The Sobriety Project, 1993).
Daniels, Gerald and Les Dench, *Passengers No More* (Ian Allen, 1980).
DB Marine catalogue, www.db-marine.co.uk
Fisher, Stuart, *Canals of Britain: A Comprehensive Guide* (Adlard Coles Nautical, 2009).
Hadfield, Charles, *The Canal Age* (David & Charles, 1968).
Hoole, K., *A Regional History of the Railways of Great Britain, Volume 4: The North East* (David & Charles, 1965).
Leeds and Liverpool Canal (2nd Edition) (Geo Projects, 2008).
Nicholson Guide to the Waterways (5) – North West and the Pennines: North West and the Pennines No. 5 (Collins, 2003).
OS Map Seventh Series, 94 & 100 (1958).
Pearson, Michael, *Canal Companion: Pennine Waters* (J. M. Pearson & Son, 2004 ed.).
Rolt, L. T. C., *Narrow Boat* (The History Press, 2010).
Rothwell, Catherine, *Lytham St Anne's in Old Photographs (Britain in Old Photographs)* (Sutton Publishing, 1993).
Saltaire Village, www.saltairevillage.info/tourist: tips info for teachers and visitors
Smith, Peter L., *Canal Barges and Narrowboats* (Shire Publications Ltd, 1975).
Smithett, Robin, *Precious Cargo: Fifty Years of Hotel Boating* (Waterways World, 2000).
Wheat, Geoff, *Canal Transport Ltd* (Malwand, 1999).